ESTORICK COLLECTION
OF MODERN ITALIAN ART

UMBERTO ALLEMANDI & C.

TURIN ~ LONDON

INDEX

Preface

Although the first formal steps were only taken towards the end of my father's life, it has always been my parents' wish that their collection of twentieth century Italian art remain together and on public display. The collection, as it existed at the time, was exhibited at the Tate Gallery in 1956 and for many years the most important pictures remained there. Despite my father's American nationality (and his childrens') it was however felt appropriate that the collection should return to England where, with his unique library of related books, it could be seen to best advantage. With great good fortune Northampton Lodge was purchased by the Trustees, but it is only through the generosity of the Heritage Lottery Fund that the necessary renovations could be undertaken to provide six galleries, art library, café and shop. My sister, Isobel, and I are deeply grateful to Lord Rothschild and his colleagues for their faith in an enterprise which, it must be said, fills a large gap in national holdings of Italian art of the period. Carol Hubbard, Anna Somers Cocks, Barry Stow and Jane Stancliffe have been tireless in their efforts on our behalf.

No project of this scale is successful without a team of committed professionals: the architect Nathaniel Gee, Stuart Trogal, Philip Warren and Paul Bell. Nathaniel's solutions to the problem of displaying the pictures with great flexibility in what is an early nineteenth century domestic house (with side wings) are both imaginative and user-friendly, avoiding the often disconcerting feel of a museum while making the art accessible to adults and children alike.

We also thank Mr Umberto Allemandi for generously producing this catalogue of my parents' bequest, Dr Benedetta Bini, Director of the Italian Cultural Institute, Dr Sandra Pinto and Dr Livia Velani of the Galleria Nazionale d'Arte Moderna, Rome for collaborating with the Foundation on the recent exhibition of the Estorick Collection held in Rome which has made this publication possible; finally to Ray Perman, Managing Director of Grosvenor Gallery (Fine Arts) Limited and his fellow directors for their great generosity in sponsoring the opening of the Estorick Collection of Modern Italian Art in its new home at Northampton Lodge. Though richly endowed with art the Foundation has only very limited funds, and it is no overstatement to say that the realisation of this dream would not have happened without the dedication, experience, imagination and persistence of our curator, Alexandra Noble, who, surmounting obstacles which would have impeded even the most hardened and stoical curator, has seen this project through to a conclusion which would have surprised and delighted my parents, as ideal a solution to a dilemma which long absorbed my father as could have been found.

MICHAEL ESTORICK
Chairman

Eric Estorick: a life in pictures

ALEXANDRA NOBLE
Curator of the Eric and Salome Estorick Foundation, London

Eric Estorick was driven by a passion for the visual arts which began in his late teens and lasted until his death in 1993. He has explained his condition in medical terms: "It was as if the creative artist was my artificial lung; as if I was a person who could breathe only when I was close to art"[1]. His achievement, shared with his wife Salome, was to assemble a collection of hundreds of paintings, drawings and sculptures from major (and some minor) figures of the European, modernist avant-garde. The Estoricks, who began collecting seriously in a furious burst after the Second World War, were never followers of the prevailing fashion but preferred to be guided by their eyes and their instinct and the advice and introductions of close friends. In this way they made a collection which from the mid-1950s and into the 1960s was considered the most important outside Italy for its selection of Italian artists.

This essay concentrates on Eric Estorick (for he was the active partner), the growth of a private collection and how Italian artists became such a preoccupation of his during the 1950s. It also discusses his motivations and why he made a series of artistic choices which, in hindsight, show extraordinary prescience. Any analysis of the Estorick collection will always come up against the inherent contradiction of the man. Estorick described himself as a "pure collector" until 1956, the year of the successful showing of "Modern Italian Art from the Estorick Collection" at the Tate Gallery[2], but his archives tell a different story of a collector who was already an emerging dealer, who found himself swayed by the power of market forces and commercial opportunities. The art dealer in Estorick eventually took over and the collection which survived to his death included works of art (many Italian) which he had made available for sale from the 1960s. Even so, Eric Estorick appears to have had a strong, emotional attachment to the inner core of his collection - the acknowledged masterpieces which any museum would be proud to own. These were beyond price.

EARLY LIFE IN NEW YORK

Born on 13 February 1913 in Brooklyn New York, Elihu Estorick[3] was the only child of Jewish parents who emigrated from Russia in 1905. His father, Morris, ran a paint business (he invented a machine which produced paint charts) and the family made an adequate living. As a child, self-conscious of his physical shortcomings, Estorick dreamt of being an artist (of some kind);

but if not an artist he was determined to be part of a creative milieu. Certainly he was gifted academically, attending New York University at Washington Square College in 1930. This was the year after the Wall Street Crash and the beginning of the Depression. As Estorick recalls:

> It was certainly a time of argument, meetings, political action... a time when on the street corners of New York City men were selling apples... to find some way to scratch a living. The poverty in all the big cities throughout the United States was apparent and the Wall Street Crash had an effect, not only on lower class people, but even on the members of the bourgeois class who regularly jumped out of windows because they couldn't maintain their standard of life... The slogan of Mr Herbert Hoover had been: "A chicken in every pot, two cars in every garage"; there was something terrribly hollow about this credo of American life. At this time there was the first gathering together of artists and writers into protest organisations against the state of the American economy[4].

Estorick completed his B. A., majoring in Sociology in 1934, and an M. A. the following year. He then continued his studies at the New School for Social Research. Although the Estorick family were not too adversely affected by the Depression, Estorick supplemented what money his family could give him for his university education by writing articles[5], which brought him into contact with writers and critics such as James T. Farrell, Erskine Caldwell, Edward Dahlberg and Joseph Freeman and actors, writers and directors connected with The Group Theatre, including Harold Clurman. This was a left-wing milieu and by 1935 he was a research secretary to Waldo Frank (1889-1967); Frank was an important radical writer and doyen of left-wing intellectual New York[6]. While working for Frank he met Malcolm Lowry, poet and best known today as author of *Under the Volcano*. Their meeting is recalled in a recent biography of Lowry: "The twenty-two-year-old Estorick, later biographer of Stafford Cripps and well-known London art dealer, was much taken with Lowry, never having met so committed an artist before. Lowry, in turn, fell in love with Estorick's family, and liked nothing better than sitting in their kitchen eating chopped chicken livers and enjoying the exuberant warmth of a New York Jewish home"[7]. Two developments which were to prove crucial to Estorick's later career as a collector and dealer occurred during his university days. The first was his discovery of The Gallery of Living Art in Washington Square College. This remarkable collection created by Albert Eugene

Gallatin, a multimillionaire collector, art historian, writer and artist was famous for Fernand Léger's "The City", Juan Miró's "Dog Barking at the Moon", Picasso's "Three Musicians" and masterpieces by Hans Arp, Constantin Brancusi, Georges Braque, Giorgio de Chirico,

1. Filippo de Pisis, "Still Life with Butterflies", 1926, oil on board 55.2 x 72.4 cm.

Paul Klee, Henri Matisse and Piet Mondrian among others. The collection was a major influence on young New York artists Arshile Gorky, Ad Reinhardt, Willem de Kooning and Philip Guston eager to see developments from Europe. It was open daily in an informal setting and remained easily accessible to all-comers from 1927 until 1942[8]. The effect of the Gallatin Collection on the young Estorick was profound and when he began collecting himself, his preference was always for art made between 1890 and 1930. The second were his encounters with Alfred Stieglitz (1864-1946), the great American photographer and founder of the gallery "291" on Fifth Avenue, whom

2. Carlo Carrà, "La stella", 1916, oil on board 60.3 x 51.7 cm.

he met through Waldo Frank. Estorick was frequently invited to dinner at Stieglitz's home and has said, "Meeting Stieglitz was one of the most important experiences of my life, bringing me to the heart of the world of art"[9]. Stieglitz had shown emerging masters of the European avant-garde during the first two decades of the century (Picasso in 1911, Picabia in 1913, Brancusi in 1914 and the Italian Futurist, Gino Severini, in 1917) at his gallery '291' and owned a substantial number of works by the latter artist[10].

It was during this period in the 1930s that Estorick also met Florence Cane, a Lecturer on Creative Expression, who was attached to the School of Education and ran a clinic for gifted children at New York University. She was an extremely cultured woman and encouraged Estorick in his love of art. One of the first works of art Estorick ever bought came from her collection, a Modigliani drawing of a caryatid (now in an American private collection); the proceeds of his various writings went towards the $100 purchase price.

In 1938 he was made Hayden fellow in Sociology and remained at New York University as an Instructor of Education teaching sociology courses between 1939 and 1941. Although he wanted to join the armed forces at the outbreak of war, Estorick's defective vision (colour blindness) precluded it. Before entering the United States Government Service in the Federal Communications Commission in 1941, Estorick was associated with a Rockefeller Foundation research project to study totalitarian propaganda techniques. He later became Head of the British Empire Division of the United States Government's Foreign Broadcast Intelligence Service and in 1942 was loaned to the Canadian Government to help plan and organise its Broadcast Intelligence

Organisation. In 1941 Estorick published his first biography of Sir Stafford Cripps, who at this time was Britain's ambassador to Moscow[11]. He also began writing introductions to a series of books by Commonwealth leaders[12], before concentrating in the immediate post-war period on his second biography of Sir Stafford Cripps, who was the Labour Government's Chancellor of the Exchequer, and considered by many to be the Prime Minister-in-waiting[13]. Working on the Cripps biography gave him access through correspondence and meetings to the leading politicians of the day - Winston Churchill, Anthony Eden, Hugh Gaitskell and Aneurin Bevan. It was also a personal introduction made by Stafford Cripps's daughter Peggy that was to change his career forever.

THE MAKING OF A COLLECTION

In 1946 Eric Estorick returned to Europe. He was there at the outbreak of the Second World War and had visited Paris in 1938 which he has described "as if I had entered Paradise"[14]. At that time most of his knowledge of French art and culture was limited to what he had seen at the Gallatin Collection and articles in "Transition" (edited by Eugene Jolas) which he collected throughout the 1930s. Estorick also followed the activities of Americans living in Paris such as Ernest Hemingway, with whom he corresponded, and Ezra Pound. He was also aware of the contribution Gertrude and Leo Stein had made to the early recognition of Juan Gris, Henri Matisse and Pablo Picasso. His return to Europe in 1946 was to complete work on his Cripps biography. He also began to buy drawings by Pablo Picasso, Juan Gris, Fernand Léger and Georges Braque[15]. For Estorick these earliest acquisitions symbolised a rite of passage into manhood, and were central to his development "as a spiritual and artistic essence"[16].

He returned to the United States as he was contracted to write a book on Sweden which was never published, but was again in Europe in early 1947. On returning to New York on the Queen Elizabeth ocean liner he met Salome Dessau (1920-1989) the daughter of textile manufacturers, Henry and Regina Dessau, who had left Leipzig for Derby, England, in 1932. They finally settled in Nottingham, and ran Jersey Fabrics (later Jersey Kapwood, subsequently taken over by Carrington Viyella). The Dessaus were very successful, supplying underwear to Marks and Spencer. Salome went to art school in London (The Reimann School), specialising in textile design. During the Second World War she was a sergeant in the Royal Air Force, decoding German signals and interrogating prisoners-of-war[17].

Eric Estorick and Salome Dessau were engaged by the end of their sea voyage to New York and married on 12 October 1947 in Nottingham. The Estoricks then took an extended honeymoon in Arosa, Switzerland. Whilst there, Peggy Cripps was a frequent house guest and introduced the Estoricks to Arturo Bryks. Bryks was an art therapist and teacher, whose wife had taught at

the Bauhaus. It was Bryks who introduced Estorick to Umberto Boccioni's book *Pittura scultura futuriste* (1914)[18]. For Estorick this was the beginning of his Italian adventure in art. Futurist art and Estorick's identification with it has been explained by the collector thus: "A boyhood life in the metropolitan oasis of New York was Futurism in action, simultaneity of vision and motion"[19].

Before returning to England the Estoricks travelled to Milan, and with Bryks visited Mario Sironi's studio at 7, Via Domenichino. That Sironi had been a major and successful artist under the Fascist regime did not deter Estorick, for the sight of forty years of art reaching back to Sironi's involvement with the Futurists was

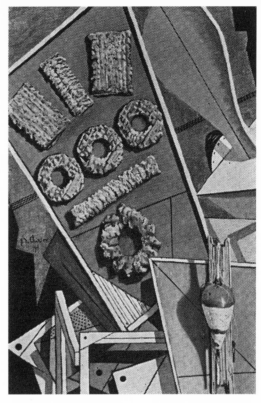

3. Giorgio de Chirico, "Metaphysical Interior", 1917, oil on canvas 45.7 x 29.8 cm.

what fascinated him and he subsequently purchased "hundreds and hundreds of drawings and as many pictures as I could get into my Packard Convertible Roadster"[20]. The collection also included twelve manuscript pages of Sironi's thoughts on art and recollections of his artistic past. A receipt dated 24 April 1948, signed by Sironi and witnessed by Bryks says: "Ho venduto pitture e disegni al Signor Eric Estorick per la somma di lire (italiane) 550.000 - ricevendo ora L. 200.000 - Il resto riceverò dopo l'esposizione, delle mie pitture, da Sr. Estorick. (Questo è un contratto privato, e non trasferibile)"[21]. No detailed inventory of works survives, but it appears that Estorick purchased almost everything in his studio at the time, particularly drawings from the Futurist period. (Most drawings, however small, were signed by the artist).

A letter from Sironi to Bryks dated 14 April 1949 shows that Sironi was still awaiting the balance of monies from Estorick and official news of his exhibition. This must have been the first English exhibition of his work held between 26 October and 27 November 1948 at St George's Gallery, 81 Grosvenor Street, London W1. What role Estorick played in the St George's Gallery exhibition is not known, but it appears that the abundant material obtained from Sironi was on the understanding that some should be sold to benefit the artist. Sironi had heard very favourable reports through English friends about his exhibition and was frustrated by Estorick's silence; the latter had only been in touch to ask for more paintings for shows he could organise in Paris and New York. How this situation was resolved is again not known, as no correspondence between Sironi and Estorick exists. However, Estorick continued to buy Sironi's work,

4. Gino Severini, "Woman at the Window
(Portrait of Mrs Paul Fort)", c. 1914,
pastel and collage on board 65.4 x 50.8 cm.

and exported it through the Galleria dell'Obelisco in Rome[22]. For Estorick the art of Mario Sironi was central to the formation of his collection and occupies a prominent place to this day, but on nothing like the scale of the 1950s, for Estorick soon discovered that Sironi was saleable and over the years his vast collection was mostly sold on or donated to museums[23]. Another artist Estorick met in 1948, again through Bryks, was Massimo Campigli. Estorick was immediately drawn to Campigli's enclosed, timeless and serene world occupied by langorous women. Campigli's handling of subject matter, in step with the return to traditional values espoused by "Novecento" artists like Sironi, and a palette inspired by Egyptian painting and Etruscan frescoes, brought Campigli international recognition in the 1930s. Campigli and his second wife, the sculptor Guiditta Scalini, developed a close relationship with the Estoricks. Campigli often invited Estorick to watch him work in the studio:

> He very rarely primed his canvasses... Not only did he work right onto the canvas but he worked with a broad brush and a... heavy laying down of paint in his strokes. An analysis of his pictures would reveal that he would paint broad monochromatic areas... he began with a razor to achieve flatness by pulling off the thickness of the layered paint... From time to time I had the feeling that he was observing the grain of the canvas through the paint[24].

Campigli was a prolific letter writer and the correspondence between the collector and artist from 1948 to 1967 documents both their personal and professional relationship. While Estorick's actual relationship with Mario Sironi remained ambiguous, there is no question of the affectionate esteem Estorick and Campigli held for each other. By 1950 (Campigli's first exhibition in England was held at the St. George's Gallery during July 1949), Estorick owned nine oils, two monotypes and fifteen drawings. He kept buying Campiglis, either directly from the artist or from selected dealers in London and Italy and at one time owned between eighty and ninety pictures and several volumes of his prints. (Campigli also did special drawings for Estorick's children). In 1953 he purchased three major oil paintings from Francesco Anfuso, including "Il Belvedere" (cat. 10)[25].

If Estorick needed any official confirmation that his developing instinct for Italian art was

justified, this came in 1949, when James Thrall Soby and Alfred H. Barr put together the major exhibition "XX Century Italian Art" held at the Museum of Modern Art in New York. In their introduction Barr and Soby rightly pointed out that Italian art had been neglected in America because it had been overshadowed by the achievements of artists working in Paris at the turn of the century and by the wealth of Italy's past. The exhibition showed first rate examples of the Futurist artists Balla, Boccioni, Carrà, Russolo and Severini. It identified the protagonists of the short-lived Metaphysical School (c. 1917-1921) as Carlo Carrà, Giorgio de Chirico and Giorgio Morandi and looked at artists Modigliani and Campigli who had worked for the most part outside Italy and defied any grouping or categorisation. It charted the "Novecento" movement, which came about in the early 1920s calling for a revival of more traditional subject matter. Artists associated with "Novecento" included Arturo Tosi, Pio Semeghini, Felice Casorati and Mario Sironi. The counter-attack in visual terms, launched in 1930, was identified as the Roman School, comprising artists Scipione (Gino Bonichi) and Mario Mafai. It also documented the latest developments of the "Fronte Nuovo delle Arti", instigated immediately after the Second World War by Renato Birolli, Guiseppe Marchiori and Emilio Vedova, whose most famous protagonist was Renato Guttuso, as well as works by the leading sculptors of the day Emilio Greco, Arturo Martini, Giacomo Manzù and Marino Marini. The exhibition catalogue published the names of all the relevant collectors. Already the Museum of Modern Art had a good representation of works and significant loans came from American private collections. All other loans came from Italian public and private collections.

Estorick must have carefully noted the exhibition's curatorial emphasis and details of lenders, given the shape of his exhibition at the Tate Gallery in 1956. He would have seen that the only Futurist work in the exhibition from an English source was Gino Severini's "The Boulevard"

(cat. 56) owned by Frederick Mayor, a respected, London dealer and gallery director. Estorick knew Mayor (he prepared all the valuation lists for insurance purposes on Estorick's growing collection in the early 1950s) and in 1951 "The Boulevard" became the first major painting by a Futurist artist acquired by Estorick. He later acquired (in 1956) one of Boccioni's studies for "The City Rises" (cat. 4)

5. Ardengo Soffici, "Futurist Landscape", also known as "Synthesis of an Autumnal Landscape", 1913, oil on canvas 45.2 x 43.2 cm.

then owned by Romeo Toninelli[26]. In 1950 Estorick visited Benedetta Marinetti, artist and widow of F. T. Marinetti, Futurism's founding father, and purchased two drawings and one painting - Umberto Boccioni's "Plastic Dynamism: Horse + Houses" (cat. 8), "Portrait of Mlle Suzanne Meryen of Varietà" by Gino Severini (cat. 53) and Ardengo Soffici's "Decomposition of the Planes of a Lamp" (cat. 78). It is perhaps surprising, given the extent of Benedetta Marinetti's collection at that time, that Estorick did not purchase more significant works[27]. Certainly financing acquisitions does not seem to have been a problem. Also, the market for Italian art was relatively untested, given Italy's isolation during the Fascist years and many Italian artists' subsequent lack of contact with other Western countries. Moreover, collectors such as Eric Estorick were able to exploit the purchasing power of American dollars and English pounds against the weakness of Italian lire. The economic chaos that ensued in Italy in the post-war period meant that some artists or their heirs were in financial straits and forced to sell works of art to survive (and sell them cheaply).

While the cost of living in England had trebled since 1939, it was said that in the early 1950s the cheapest thing you could buy was a work of art[28]. From 1945 until 1952 the art market in London was adversely affected by a lack of confidence in the future brought about by the effects of a prolonged global war. There was also no free movement of currency, which restricted the art market's international potential but a sharp rise in prices began in 1954, when London once again found its pre-war position as the centre of the international art market, due to the British Government lifting currency regulations (enacted in 1940), allowing imported works of art and antiques to be paid for in the currency of the nation they were received from. This brought many foreign buyers and sellers to London auction houses. Much new money was invested in art and, while most of it came from the United States, London was the focus for the new rich of France, Greece, Switzerland and Asia. In the mid-1950s the British Government also allowed valuable works of art to be accepted separately in lieu of death duties. This contributed to the auction boom.

In the late 1940s and early 1950s Estorick's interest was not limited to Italian artists alone and as early as 1949 he exhibited twenty-eight paintings and drawings at the Midland Group in Nottingham[29]. Although the handlist gives few details, it is the earliest surviving record of his preferences in Italian and French art. It was also the first public exhibition of a collection, which had begun in earnest only two years earlier. It demonstrates both Estorick's philanthropy, in sharing his enthusiasm for art with a broader public, coupled with a canny understanding of the future benefits such promotion could bring him personally. In 1950 another exhibition took place, this time at the headquarters of Marks and Spencer in Baker Street, London. On display for three weeks from 14 October were the following pictures, "Rouault Christ on the Water...

Vlaminck Street Scene... Blatas Ladies in Bistro... Derain Design for Tapestry... Lurcat Shipwreck, Severini Two Still Life..."[30]

Estorick, who had completed his second biography on Sir Stafford Cripps in 1949, was taken on at Marks and Spencer between 1950 and 1953[31]. This job came about through the close contacts his wife's family had with the firm (his uncle was also married to a sister of Israel, later Lord Sieff). His wife wanted to stay in England and raise her young family (Isobel was born in 1948 and Michael in 1951); she was also a senior executive in the Dessau family firm. Eric Estorick's increasing forays into both collecting and the commercial art world were governed by his need to earn a living in England. Resuming his academic career no longer seemed an option.

Estorick's role at Marks and Spencer was to put the company's archives in order and to write a history of the business; he also put on art exhibitions in the Executive Dining Room. He used the Marks and Spencer address for an increasing volume of art transactions. Such a sharp increase may be explained by his appointment in 1950 as the English representative of the Sidney Janis Gallery, New York[32].

The common strand linking his purchases of Italian and French artists was his overwhelming interest in figurative art. Apart from the Marinetti visit and the purchase of Marino Marini's "Quadriga" (cat. 31) in 1949 and "Pomona" (cat. 32) in 1950, Estorick made relatively few Italian purchases at this time[33]. Instead, until 1953 he was buying considerable numbers of canvases by Bernard Buffet, Camille Bombois, Antoni Clavé, André Civet,

6. Filippo de Pisis, "Hommage to Rossini", 1940, oil on panel 33.4 x 46 cm.

Serge Ferat, Francis Gruber, André Marchand, André Minaux, Claude Venard and Louis Vivin, mostly from Galanis-Hetschel, Paris. Throughout the Fifties he continued to promote and purchase major and minor Realist painters working in France[34], but he did not get quite the recognition for the French artists in his collection as his public touring exhibitions of Italian artists which began in 1954[35].

Estorick's collecting of Italian artists really gathered momentum between 1953 and 1958. His desire to make a great collection of Italian art was not only governed by particular artists matching his taste as a collector, but also by shrewd, financial considerations. By establishing

a collection that represented major, Italian artists at work between 1900 and 1945 and promoting these same artists through a series of public exhibitions, Estorick would gain notice and critical credibility for his selection. This recognition would then enable Estorick to capitalise on any re-sales he might make. This argument is borne out by a correspondence during the 1950s between Estorick and Donald Blinken. Blinken, a family friend and senior executive for Stein's Stores, a top American clothing chain, formed a two year partnership with Estorick from September 1953[36]. Their objective was "to buy a number of pictures, principally by the so-called 'Futurist' and 'Metaphysical' painters, with a view to promoting and then reselling these pictures for a capital gain. We shall concentrate on works by the following: Boccioni, Balla, De Chirico, Carrà, Russolo, Soffici, Severini. If any unusual opportunities to buy other Italian painters' works of the period 1900-1925 present themselves, we will take advantage of them..."[37] Each man put $10,000 into a Swiss bank account and Estorick had sole discretion in deciding what to buy.

This partnership ran concurrently with the first public tour of Estorick (and Blinken's) collection entitled "Contemporary Italian Art". It was organised by Helen Kapp, the enterprising Director of Wakefield Art Gallery, who had invited Estorick to take part in another exhibition the previous year[38]. Estorick saw then the opportunity for a much bigger collaboration and approached Kapp who was keen to show further international, contemporary works of art in Wakefield and also helped organise a tour to other regional city centres and enlisted the Arts Council of Great Britain to undertake the transportation. The arrangements for such an exhibition were ongoing throughout 1953. The result was an exhibition of 136 works of art (fourteen owned by Blinken) which travelled for nine months[39].

In 1953 Estorick concentrated on improving his Italian holdings; he had the dual incentive of the exhibition with Kapp and the partnership with Blinken - collecting and commerce in tandem. He made at least two trips to Italy in February/March and again in October/November. In February he obtained from Dr. Francesco Anfuso three Campigli oils[25]; Filippo de Pisis "Still Life with Butterflies" (fig. 1); Mario Tozzi "Head of a Woman" and two Severini compositions, one an oil on canvas, the other an oil on cardboard. From the Galleria del Milione in Milan he acquired Carlo Carrà's "La stella" (fig. 2)[40]. The Carrà was part of an exhibition of forty-nine works exhibited at the Galleria del Milione during November 1952[41]. Also shown were major Futurist works: Umberto Boccioni's "Unique Forms of Continuity in Space", 1913, bronze, and "Elasticity of a Horse", 1912, oil on canvas; Giacomo Balla's "Mercury Passing before the Sun Seen through a Telescope", 1914, tempera on paper; Carlo Carrà's "The 'Galleria' in Milan", 1912, important metaphysical works including "The Engineer's Mistress" of 1921 and Ardengo Soffici's "Self-Portrait" of 1912 and an oil collage on canvas entitled "Typography" of 1914. Estorick, with pressing ambitions to collect Futurist works could not do so, as these important paintings were

already in Italian private collections, including those of Emilio Jesi, Riccardo Jucker and Gianni Mattioli.

With his forthcoming exhibition in mind Estorick therefore concentrated on more contemporary artists, some for immediate resale. A shipment list prepared by the Galleria dell'Obelisco, Rome, and dated 12 March 1953 showed that of thirty works listed four were by Gino Severini (including the first mention of "Quaker Oats - Cubist Still Life" [cat. 54]) and "Plastic Dynamism: Horse + Houses" by Boccioni; the rest included four Campigli, two Fausto Pirandello, six Zoran Music, three Renzo Vespignani, a De Pisis, a Mario Tozzi, an Aldo Pagliacci and seven Nino Caffé[42]. Only two of the seven Caffé's, for example, are

7. Fausto Pirandello, "Man with Striped Pyjama Jacket", 1952, oil on board 90.2 x 68.6 cm.

listed on Estorick's insurance valuation list dated 23 September 1953 - the remainder were sold on. This same valuation reveals Estorick's preference for De Chirico; it included De Chirico's oil paintings "Greetings of a Distant Friend" and "The Revolt of the Sage" (cat. 23) from Roland Penrose, "Metaphysical Interior" (fig. 3) also from Penrose, "Self-Portrait" and "Metaphysical Family". In addition to the Severinis he had shipped from Italy there is also "Woman at the Window" (fig. 4) and "Dancer (Ballerina + Sea)" (cat. 57), an Ardengo Soffici landscape (fig. 5), Giacomo Manzù's "Bust of a Woman" (cat. 29), three Marini oils, four sculptures and "Horse and Rider" (cat. 33)[43]. By November an invoice this time from Vittorio E. Barbaroux in Milan listed two Morandi still lifes, Filippo de Pisis's "Homage to Rossini" (fig. 6), Boccioni's "Seated Woman (Artist's Mother)" (cat. 5) and a sculpture by Arturo Martini entitled "The Swimmer"[44]. Letters from Emilio Greco, the Campiglis and Fausto Pirandello demonstrate Estorick's direct contact with some contemporary artists. During this hectic period Estorick was shipping works of art by these artists simultaneously to England for exhibition and to New York for sale. Fausto Pirandello, the son of the playwright, had works purchased by Estorick (fig. 7), but also lent others on consignment for the duration of the English tour, on the understanding that if they were sold Estorick would repay him in full. Estorick also acquired from Francesco Monotti in Rome an Ottone Rosai (cat. 50) and two Bruno Cassinari portraits of the artist's mother. In this way the show of contemporary Italian art for Wakefield was made.

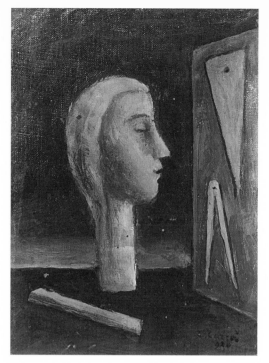

8. Carlo Carrà, "The Engineer's Mistress", 1920,
oil on canvas 24.1 x 17.8 cm (private collection).

In England press reaction was interested and, for the most part, complimentary. Reviewers took their lead from Robert Melville's essay in the English edition of the catalogue, re-drafted for publication as a review in "The Studio" (May 1954). All reviewers repeat Melville's point that key works by the Futurists were in public collections by the time Estorick (and Blinken) started to collect. With hindsight, this is known only to be partially true; many major works were still owned privately in Italy, Europe and the United States and periodically came onto the market during the 1950s. Reviewers compared the Futurists with French painters of the period; Severini, in particular, best represented in the exhibition, was criticised thus: "His 'The Boulevard' of 1910 relied heavily on both the Renoir of the 1880s and upon the pointillist technique of Seurat and Signac, while a few years later he had become hardly more than a follower of the cubists, and of Gris in particular..." while Morandi and Campigli came in for the highest praise, and overall the exhibition was described as "admirable"[45]. The Irish press had a more mixed reaction. Controversy arose when the insurance value of the exhibition became known to be £43,000 and one Belfast Councillor, a Miss McAlery, said the works in the exhibition and its frames were worth only £25[46]. Such press diversions did not detract from the overall seriousness of the reviews, and many asked why a survey of contemporary Italian art had only come from two collectors, and how comprehensive or impartial such a selection could be. Some reviewers wanted to see artists working in a more abstract way and suggested the inclusion of Afro (Basaldella); Guttuso was also considered another omission[47].

Estorick's acquisitions in 1954 and 1955 were conducted at a more leisurely and considered pace. He not only made some of his more memorable purchases but also started to exchange paintings to upgrade his collection, as all serious collectors do[48]. It was in London that Estorick found rare Futurist pictures. In September 1954 he purchased Giacomo Balla's "The Hand of the Violinist" (cat. 1) from Alex Reid & Lefevre. This was a major coup, as already Estorick knew "Dynamism of a Dog on a Leash" (Albright-Knox Art Gallery, Buffalo) and "Girl Running on a Balcony" (Civica Galleria d'Arte Moderna, Raccolta Grassi, Milan). These three paintings from 1912 address the Futurist concern of how to depict the sequence and continuity of movement, but "The Hand of the Violinist" was perhaps Balla's most mature solution of the technical

problems involved. In March 1955 Boccioni's "Modern Idol" (cat. 3) and a drawing after "States of Mind: The Farewells" (cat. 9) came up at the Marlborough Gallery and in June he acquired Giorgio de Chirico's "Melanconia" (cat. 24) from Peter Watson, one of the Directors of the London Gallery. In the same month, after already knowing Renato Guttuso for some years, he bought "Death of a Hero" (cat. 27) from the Leicester Galleries.

Count Umberto Morra, Director of the Italian Cultural Institute made the initial approach in early 1956 to John Rothenstein of the Tate Gallery to collaborate on what was to be called "Modern Italian Art from the Estorick Collection". Estorick was keen to include works from other collections, rather than have another solo exhibition of his collection but the Arts Council vetoed this suggestion on the grounds of cost. English reviewers of the exhibition would not have known of Estorick's failure to have his collection seen alongside others[49]. Knowing that the Tate exhibition was likely to be arranged for later in 1956, Estorick once again returned to Italy and embarked on another major buying trip. This time he met some of the now-elderly figures of Futurism, including Giacomo Balla and his daughters; Renato Guttuso made the introduction. From this visit he purchased some early Futurist drawings, but only kept one (cat. 2); the others were for an American collector called Joseph Slifka. Evidently, the tension for Estorick between trying to better his own collection and buy for someone else was acute[50]. He also met Carlo Carrà, and his son Massimo. Carrà sold him several early Futurist drawings, "Boxer" (cat. 21) and "Synthesis of a Café Concert" (cat. 22). He also purchased an oil sketch for "The Engineer's Mistress" (fig. 8) which later caused controversy[51]. Estorick had encountered Gino Severini quite a few times in Paris and Italy during the 1950s. Severini would travel to Italy on

holiday with his family with a few pictures in his suitcases, in the hope that he would sell something[52]. In 1956 Severini suggested that he did a pen portrait of Estorick (fig. 9). After several attempts which he threw in the waste-paper basket, he sent Estorick one from memory to London a week later[53]. Estorick also met Ardengo Soffici at this time and bought drawings directly from him (cat. 79) and continued to see Morandi at his studio in Bologna which he had visited since the late 1940s. Another Estorick coup was a meeting with the

9. Gino Severini, "Portrait of Eric Estorick", 1956,
pen and ink on paper 23 x 19 cm (private collection).

widow of Luigi Russolo, who sold him "Music" (cat. 52) in March 1956. As in 1953, the traffic of purchases from Italy to England was regular. The 1956 exhibition contained Estorick's new acquisitions, thereby consolidating the earlier Futurist and Metaphysical periods with the addition of Balla, the Boccionis, Carràs and Russolo, otherwise the selection was broadly similar to the 1954 exhibition. Modigliani drawings were lifted by the inclusion of the late oil portrait of Dr Brabander (cat. 34) which Estorick acquired from a New York dealer. Morandi, Campigli and Sironi still maintained the strongest representations[54].

The Tate showing created enormous press interest in both Italy and Britain. The selection of sculpture by Greco, Manzù, Marini and Di Giorgi came in for unqualified praise, but for many critics one fourth of the show given over to Campigli and Sironi seemed overweighted, although they recognised Estorick's particular passion for the work of Campigli. The four metaphysical De Chiricos were much praised, but Morandi's oils were considered minor works. The Futurists in no way achieved a consensus. There was, for instance, the "Burlington Magazine" (December 1956) saying that Boccioni's "Idolo moderno", Russolo's "Musica" and De Chirico's "Melanconia" were all worthy of a public collection, and Quentin Bell, writing in "The Listener" (6 December 1956), said, "Boccioni, who is indeed unpleasant, seems inept; his "Idolo Moderno" must surely be the worst picture now hanging in the Tate..." "The Times" on 21 November 1956 agreed with "Boccioni 'Idolo Moderno'... whose laughable crudity..." while Russolo's "Musica" was considered "really rather dreadful" by the critic of the "Manchester Guardian" (22 November 1956) and "The Times", quoted above, described "Musica" as "an enormous Russolo of excruciating vulgarity". The absence of new abstract painters was once again noted, with regret. Even if particular pictures or artists did not please certain critics the tone of most reviews was intelligent and informed. It was only the Futurists who were damned with faint praise or compared unfavourably to their Cubist counterparts[55]. While the exhibition went on another regional tour Estorick continued buying[56]. He already had another exhibition planned, this time collaborating with the Galleria del Milione in Milan and Marcello Mascherini, a bronze sculptor. The result was "Italienische Kunst im XX Jahrhundert" held at the Akademie der Kunste in Berlin from 21 September to 27 October 1957. The Milione's involvement meant that more contemporary works of art were included showing the latest developments in Italian abstract art (Renato Birolli, Enzo Brunori, Arturo Carmassi, Bruno Cassinari, Alfredo Chignine, Antonio Corpora, Gianni Dova, Mattia Moreni and Sergio Vacchi). Estorick had purchased Afro and Emilio Vedova at this time, and included new Boccioni drawings acquired from the Milione. The one really significant addition was Medardo Rosso's "Impressions of the Boulevard: Woman with a Veil" (cat. 51). A Canadian tour was also arranged, after Estorick met Philip Buchanan of the National Gallery of Canada in Venice. Fifty paintings and drawings travelled

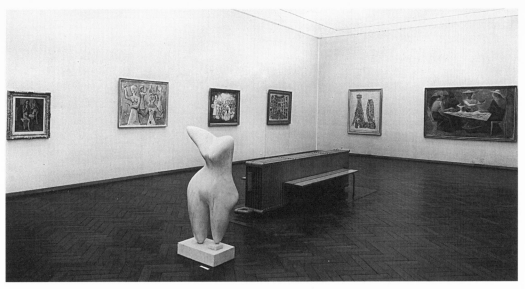

10. Photograph of the installation of Estorick's Collection at the Stedelijk Museum, Amsterdam, in 1960.
A Viani sculpture in the foreground and on the walls from left to right: Felice Casorati, "Friends" 1923;
the rest are by Massimo Campigli, including "Diabolo" 1953, "La Scala" 1951, and "Tower and Great Wheel" 1951.

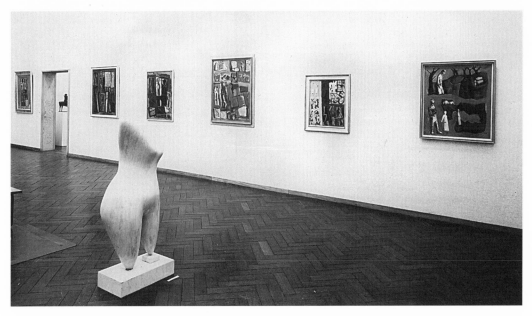

11. Viani sculpture and the opposite wall to fig. 10 on which are hung a series of five "Multiplication"
paintings by Mario Sironi.

during 1958[57]. As if this was not enough wear and tear on this hardworking collection, a showing

in Los Angeles at the Municipal Art Gallery, Barnsdall Park, was programmed for March 1959.

A further showing at the South London Art Gallery occurred from 25 October to 14 November

1959 - the catalogue listed the appearance of Carlo Carrà's "Leaving the Theatre" (cat. 20) which

Estorick had bought at auction in London the previous year. The final tour took place during

1960 to Holland, Austria and Germany (see figs. 10-13)[58].

FROM COLLECTOR TO ART DEALER

The name Estorick had made for himself through his public exhibitions campaign was now put

to good use as he relinquished collecting for full-time art dealing. As an American living in

London he was well-placed to network on both sides of the Atlantic and to this end extended

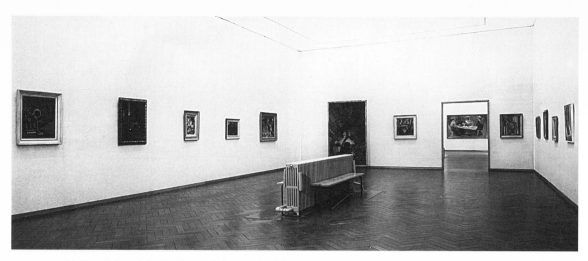

12. From left to right: De Chirico, "The Revolt of the Sage" and "Melanconia"; Soffici, "Decomposition of the Planes of a Lamp" and in the corner Carrà, "Leaving the Theatre" and Russolo, "Music"; on either side of the doorway Boccioni, "Modern Idol" and Carlo Carrà, "La stella".

and consolidated his client list in America and Europe. His success as a dealer came in part from his association with many actors, directors and producers in Hollywood. Letters written in the early and mid-1950s from Carl Foreman, a Hollywood film producer (who was on the McCarthy blacklist and living in England) and Eli Wallach, the actor, reveal that Estorick already had a foothold in a world which was to prove important as he set about opening his own commercial gallery in 1960. In the late 1950s and early 1960s Estorick was buying in the London auction rooms on behalf of Hollywood clients, his list reading like a *Who's Who* of Hollywood at the time: Lauren Bacall, Tony Curtis, Burt Lancaster, Jack Lemmon, Anthony Quinn, Milton Sperling, Edward G. Robinson, Billy Wilder and Charles Vidor all relied on his expertise[59]. In 1958 Estorick also acted as an art representative for Ann Douglas, wife of Kirk Douglas, and supplied one of their companies with advice on available works for sale, customers, suppliers and market conditions in Europe. Ann Douglas and Estorick were also partners in the selling of two contemporary Italian painters, Enrico Cervelli and Duilio Barnabè, although this did not prove a success.

On 21 and 22 November 1961 Finarte held a public auction of 166 works of art in Milan. Estorick sent 106 works of art to auction, and unfortunately some Italian paintings that had been so much part of his touring exhibitions from 1954 onwards were sold and passed out of the Estorick

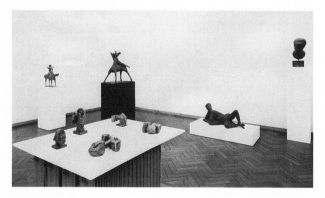

Collection forever[60]. Some of the stars from his wider collection were also sacrificed. Altogether Estorick recorded fifty-five works from his collection sold; this decision to sell is explained by Estorick's role as a gallery director

13. Installation view of the works of three sculptors: left, Marino Marini; foreground on the table, Andrea Cascella and right, Emilio Greco.

with new artistic territories to explore. Although he continued to show Italian artists at the Grosvenor Gallery, the Italian adventure was over. No major new works were acquired and further Italian pictures slipped away to finance Estorick's new interests (fig. 14). Never doing anything by halves, Estorick embarked on whirlwind tours of the Soviet Union and Eastern Europe making fifteen visits in five years (for Russian art and Czech painting) from 1960 to 1964. He also began to promote South African artists from 1965. The acknowledged masterpieces in his collection were never under threat, and lay in abeyance until the Tate Gallery requested a long term loan of key

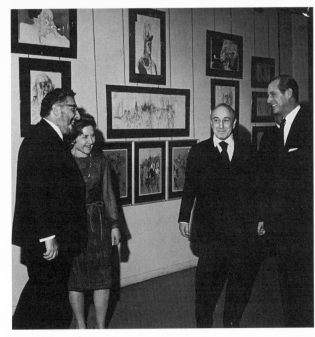

14. From left to right: Eric and Salome Estorick with Feliks Topolski, artist, and H. R. H. The Duke of Edinburgh at the opening of Topolski's exhibition at the Grosvenor Gallery from 28 February to 23 March 1968. Reproduced by courtesy of Michael and Isobel Estorick.

works from 1966 to 1975, when the Estoricks withdrew their pictures and went to live in Barbados[61]. After 1967 much of the Estoricks' business was taken up with managing the affairs, and masterminding the revival of interest in Erté, the art deco designer.

In 1968 the Italian Republic conferred on Estorick the title of *Cavaliere*, followed by the higher honour of *Commendatore* in 1970 for his services in promoting Italian art. In 1979 the Italian government showed interest in purchasing his Italian Collection, but the family refused. Various manoeuverings by several, major museums in the United States and Israel also came to nothing. Although increasingly frail after his wife's death in 1989, Estorick and his children had other ideas. In old age Estorick reminisced about the Gallatin Collection and his college days at New York University and six months before his death in December 1993 set up an American charity to which he donated his remaining Italian works (all are illustrated in this publication). He gave two paintings (a Murnau Landscape by Wassily Kandinsky and a rare Cubist Still Life by Marc Chagall) with instructions that they be sold and monies used to endow the newly formed Eric and Salome Estorick Foundation.

The family felt that Estorick's adopted home was the place for the Foundation, rather than the United States. His son, Michael, found Northampton Lodge, a Grade II listed building in Islington, North London, which was acquired late in 1994 (fig. 15). The plan was to set up a museum to house the permanent collection which had belonged to Eric and Salome Estorick and an art library donated by Michael and Isobel Estorick. As endowment monies had to be protected to meet future running costs, the newly established English charity put in an

25

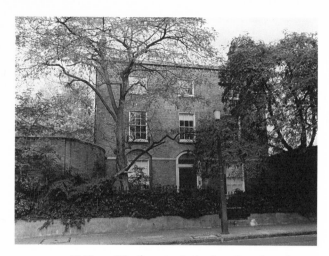

15. View of Northampton Lodge from Canonbury Square.

application to the Heritage Lottery Fund for meeting the renovation costs. The Heritage Lottery Fund gave much needed finance for the project and building works are now underway with the Foundation scheduled to open to the public in late January 1998. The renovation will provide six galleries over three floors, a library and offices on the top floor, a shop and café. In addition to the permanent collection, as future funding allows, the Foundation intends to host several travelling exhibitions a year aimed at extending the context for the permanent collection. It will also put on an educational programme for schools, and open its library, which specialises in twentieth century Italian art, to researchers. The establishment of the Estorick Foundation is an extraordinary and generous gift from one family to this country and one in which many people can share. For Eric Estorick who lived his life through art, his bequest means that others can in some way understand what he meant when he said, "I have always regarded art as being the God Centre of the Altar at which I have always knelt and in front of which I shall die and die happily"[62].

All family papers referred to and quoted in the text have been made available with the kind permission of Isobel and Michael Estorick.
Their generous co-operation over this exhibition catalogue is greatly appreciated.

[1] E. ESTORICK, unpublished memoir 1985, p. 18.

[2] *Ibid.*, p. 31.

[3] Eric was a name he adopted later. His parents always referred to him as Ely and in the 1930s he wrote under the names of both Eric Estorick and Eric Ely-Estorick.

[4] ESTORICK, memoir cit., pp. 11-12.

[5] He wrote book and music reviews for "The Home Talk Star", a weekly newspaper run by the Norwegian community in Brooklyn. Between 1938 and 1942 he was a contributor to "Nation", "New Republic", "Scribners", "American Journal of Sociology", "Dynamic America" and "Radical Religion". In 1938-1939 he was American Correspondent to the "London Tribune".

[6] E. ELY-ESTORICK, *Prelude to Immortality: The Story-Theme in Waldo Frank's World Symphony*, in "Trend", Vol. II, May-June 1934, No. 3. The publication of this article was well received by Frank, and a friendship developed between the two men which lasted many years. In a testimonial letter Frank wrote for Estorick on 30 May 1949 the latter was referred to as, "a tough, clear-eyed liberal who calls his shots with vigor and grace..."

[7] G. BOWKER, *Pursued by Furies. A Life of Malcolm Lowry*, London 1993, p. 195.

[8] Since 1943 the Gallatin Collection has been part of the Philadelphia Museum of Art. For further information see Susan C. LARSEN, *Albert Gallatin: The "Park Avenue Cubist" who went downtown*, in "Artnews", December 1978, pp. 80-82.

[9] ESTORICK, memoir cit., p. 17. Letters from Stieglitz to Estorick written in 1935 make clear the affection Stieglitz held for the younger man. He offers advice, an invitation to stay at Lake George and congratulations over Estorick finding a job.

[10] See D. FONTI, *Gino Severini. Catalogo ragionato*, Mondadori, Milan 1988, for further details on the extent of Stieglitz's holdings of Severini. Catalogue No. 141 designated as Stieglitz (?) came into the Estorick Collection in the 1950s and was No. 20 in "Modern Italian Art from the Estorick Collection" held at the Tate Gallery in 1956.

[11] E. ESTORICK, *Stafford Cripps: Prophetic Rebel*, John Day, New York 1941.

[12] The first in the series was by Walter Nash, New Zealand's Prime Minister, published in 1943; M. J. Coldwell, leader of the Cooperative Commonwealth Federation, followed with *Left Turn, Canada*, then Jan Christian Smuts of South Africa with *Towards a Better World*. This series continued through the 1940s.

[13] E. ESTORICK, *The Biography of Sir Stafford Cripps*, Heinemann, London 1949.

[14] ESTORICK, memoir cit., p. 25.

[15] *Ibid.*, p. 27. Evidently Estorick had accumulated a few thousand dollars royalties from his writings; drawings by such modern masters were priced at as little as $200. No documentation has survived but it is certainly true that by February 1949 Picasso did figure in his collection. When Estorick loaned "Contemporary European Paintings and Drawings" to the Midland Regional Group of Artists and Designers in Nottingham in that year, Nos. 13 ("Design"), 19 ("Nude"), 20 ("Brooding Head") and 21 ("Cubist Man with Pipe") were by Picasso.

[16] *Ibid.*, p. 27.

[17] I am grateful to Michael Estorick for biographical details on his mother's family.

[18] In this book were black and white illustrations of works by the Italian Futurists Umberto Boccioni, Giacomo Balla, Carlo Carrà, Luigi Russolo and Gino Severini. Literary in origin, Italian Futurism was launched by the poet Filippo Tommaso Marinetti who wrote its Founding Manifesto; this was published in "Le Figaro", the leading French newspaper, on 20 February 1909. The movement grew to embrace many different art forms - architecture, decorative arts, painting, performance and theatrical design, music, photography, sculpture, and typography. Marinetti wanted to break with the weight of Italy's cultural tradition and develop an aesthetic based on modern life and technology, particularly speed and the machine. Marinetti's impassioned polemic immediately attracted the support of a group of young Milanese painters - Boccioni, Carrà and Russolo - who wanted to extend Marinetti's ideas into the visual arts. The painters Severini and Balla met Marinetti in 1910. Those five visual artists that Estorick saw in Boccioni's 1914 publication represented the leading, dynamic impulse of Futurism's first phase.

[19] E. ESTORICK in "Italienische Kunst im XX Jahrhundert", Akademie der Kunste, Berlin 1957, n. p.

[20] ESTORICK, memoir cit., p. 30.

[21] "I have sold paintings and drawings to Mr Eric Estorick for the sum of 550,000 Italian lire - receiving 200,000 lire now - the rest I will receive after the exhibition of my pictures by Mr Estorick. (This is a private contract and not transferable)".

[22] A shipping statement from the Galleria dell'Obelisco documents twenty-six paintings by Sironi and one by Nino Caffé to New York on 20 November 1953.

[23] The Grosvenor Gallery has shown Sironi in group and one man exhibitions since it opened in 1960. Works were always available for sale; the largest was a retrospective held from 30 January to 29 February 1964 with 247 works

on display, many of which were obtained from his visit to Sironi in 1948 according to the Gallery's present Director, Ray Perman. In 1952 Estorick donated "Il sifone di seltz" (The Syphon) (1916), gouache and papier colle, and "Cinque figure" (Five Figures) (1936), tempera on canvas, to the Tate Gallery, London. Estorick gave about fifty Sironi drawings to the University of Cambridge in 1969. They are now housed at Kettle's Yard.

[24] ESTORICK, memoir cit., p. 54.

[25] The other two were "La Nave" (The Boat) of 1930 and "Donne in giardino" (Women in a Garden), probably "Donne in un giardino con palme" (Women in a Palm Garden) (1936). Both were shown in "Modern Italian Art from the Estorick Collection" at the Tate Gallery in November 1956, but were sold subsequently.

[26] XX Century Italian Art, Museum of Modern Art, New York 1949, pp. 126, 134 & pl. 20.

[27] See Futurism a Modern Focus: The Lydia and Harry Lewis Winston Collection, Solomon R. Guggenheim Museum, New York 1973. Lydia Winston Malbin formed one of the great Futurist collections in the United States just a few years later than Eric Estorick. Catalogue nos: 17, 20, 23, 28, 29, 30, 92 and 93 which are major works by the Italian Futurists were all in the Marinetti Collection and did not pass into Lydia Winston Malbin's Collection until the mid-1950s. It is known that Estorick did business with Francesco Anfuso, an Italian dealer in 1952-1953. An undated note in Anfuso's handwriting with prices scribbled by Estorick shows that five Ballas including "Mercury and the Sun" and "Threes", Russolo's "Perfume", two Boccioni sculptures and Boccioni's "Footballer", a Severini watercolour and unspecified works by Carrà and Soffici were on offer to Estorick. Given that many of these works later went to Lydia Winston Malbin, it is strange that Estorick did not purchase at least some of them.

[28] G. REITLINGER, The Economies of Taste: The Rise and Fall of Picture Prices 1760-1960, London 1961, pp. 220 and 228.

[29] Apart from the four Picassos listed in footnote 15, he included four Campigli, six Sironi, four Jankel Adler, a Signac Boating Scene, two Modigliani drawings (one of Cristiane Mancini), a Redon Nude, a Street Scene by Vlaminck, two Fougeron, an Epstein Drawing from the Baudelaire series, Serge Ferat's Composition after Braque and a Gischia Still Life.

[30] Insurance note from John Poole & Sons, 5 Whittington Avenue, E.C.3., to Eric Estorick, 17 October 1950.

[31] Estorick was initially given a seven year contract on £2,000 per year; the contract was terminated in April 1953, and Estorick received a final settlement of £6,500. An average working wage was about £300 - £400 p. a. at this time.

[32] "It is understood that all purchases, sales, consignments and any other commitments of any nature, made by you, shall at all times, be subject to my written approval and ratification. Your compensation shall be fixed on the consummation of each transaction by mutual agreement and consideration". Letter from Sidney Janis to Eric Estorick, 20 January 1950. It is interesting to note that Sidney Janis became pre-eminent from the 1950s for his exhibitions of Italian modernist art.

[33] Purchase invoices have not always survived, but a large number of insurance valuation lists prepared by Frederick Mayor from March 1950 give another record of Estorick's growing collection. The valuation list for 23 March 1950 shows Campigli as the prominent Italian artist, with Estorick owning nine oils, two monotypes, one gouache, two pencil drawings and twelve ink drawings. Also listed are "De Chirico, Melancholy of a Political Man". The list dated 9 May 1951 includes "Marino Marini, Boy and Horse, oil; Modigliani, Nature Morte - bottle, books, plate with lemons and tomato on table, Portrait of Cristiane Mancini - pencil drawing" and "Gino Severini, Nature Morte - fruit and fish on table - gouache, Nature Morte - fruit on table and leaning mandolin - gouache" and "Le Boulevard." By September 11th 1951 "Campigli Chanteuse" and "Theatre", both oils along with "De Chirico Nature Morte" have been added. The previous De Chirico has been crossed off. On July 17th 1952, "Chirico Delights of Poet oil; Modigliani Caryatid oil; Music 2 Large Landscapes with Horses" and five oils by Campigli, "Two Spinnners, Two Women with Fan, Two Bathers, Terrace in San Marco and Two Ladies Eating Ice Cream" have been added.

[34] The works purchased at this time by André Civet, Francis Gruber, and André Marchand found their way into "Ecole de Paris under 60: French Paintings from the Estorick Collection", an exhibition of forty-seven paintings which toured from February to June 1955 to the Midland Group, Nottingham, Newcastle-upon-Tyne and York City Art Gallery. A review in "The Times", 23 February 1955, was favourable. It is quoted at length because it gives a good description of Estorick's preferred taste as a collector at this time: "This part of Mr Estorick's large collection of contemporary paintings has not hitherto been publicly exhibited, though a number of the works have been seen here and there in London... It does not pretend to afford a comprehensive survey of the work of younger French painters. It is the reflection of a distinctly personal taste, one with a strong bias towards the malerisch and towards painting

concerned to express emotional rather than visual realities. There are no non-figurative works... the exhibits can be divided into three stylistic groups. One of these including... Antoni Clavé, André Marchand... and M. Claude Venard, presents us with forms flattened, schematized, and distorted in the tradition of cubism... The second group... Bernard Buffet... André Minaux... take objects normally found in kitchens and lay them out before us in a forthright yet somewhat Ritualistic manner; appearances have been crudely simplified... The third group which includes... Francis Gruber is more atmospheric and naturalistic and reveals a considerable indebtedness to the later Derain..." An exhibition of thirty-seven works entitled "XXth Century French Painting" went to Auckland Art Gallery, New Zealand, between September and October 1957 and included an older generation of artists working in Belgium - Permeke, De Smet and Van den Berghe. Louis Vivin's "Sacré-Cœur" and Francis Gruber's "Nude Sitting in Green Chair" were shown in "Paintings from the Estorick Collection" at the Hatton Gallery, Newcastle-upon-Tyne, in 1960.

[35] Estorick received an inexplicably hostile and misleading review written by W. E. Johnson in "The Times" on 7 November 1960 about the exhibition in Newcastle, mentioned above at the end of note 34, which might explain why he never lent his paintings en masse again to public exhibitions after this date. This gathering of thirty-three paintings showed the development and sophistication of Estorick's taste in figurative art during the 1950s. The exhibition showed fine examples of works by Balthus, George Braque, Marc Chagall, Robert Delaunay, André Derain, Jean Dubuffet, Max Ernst, Lionel Feininger, Alberto Giacometti, Juan Gris, Hans Hartung, Ivon Hitchens, Wassily Kandinsky, Paul Klee, Henri Matisse, Juan Miró, Ben Nicholson, Pablo Picasso, George Rouault, Henri Rousseau, W. R. Sickert, Maurice Utrillo, Suzanne Valadon and Kees van Dongen. Johnson said: "Eric Estorick, that ardent American in England, who is already known to us for his magnificent collection of modern Italian painting, is currently represented by a broader anthology of the work of twentieth century masters. Many of these paintings, campaign stars for a battle long since won, have been bought with hindsight... a disappointing Delaunay, a doubtful Derain, and an undramatic urban landscape by the ubiquitous Utrillo raise doubts as to whether this connoisseur has not fallen into the danger of autograph hunting - on a grand scale..." Kenneth Rowntree, then Professor of Fine Art at King's College, Newcastle sprang to the exhibition's defence and to the selection which he had made with a

Newcastle audience in mind. Rowntree also refuted the aspersion cast on the Derain.

[36] Although he collected works of art himself, Blinken saw the partnership as strictly business. Based in New York Blinken kept Estorick up to date with all the art world news, advised him constantly and would write urgently requesting photographs so he could make sales on Estorick's behalf. On 30 March 1952, Blinken declared an interest in Antonio (more commonly known as Zoran) Music, "Several sources, including Frankfurter think he is the leading young Italian painter". Estorick had already enlisted a personal introduction from Campigli to Music and between February and April 1952 acquired five paintings from the Galerie de France. In mid-1953 Blinken advised Estorick against buying any more Campiglis as dealers in New York had not yet established prices for his work in the United States. Blinken wanted Estorick to lend a painting to the Cadby-Birch Gallery exhibition of Sironi in September 1953. Blinken lent one from his private collection entitled "Calunnia" (Calumny), but Estorick only noted the prices, ranging from $300 - 1,000. Blinken in a letter dated 3 February 1954 also reported on an exhibition "The Futurists: Balla and Severini 1912-1918" held at the Rose Fried Gallery from 25 January to 26 February 1954. The exhibition included fifteen works by Balla and nine by Severini. The show was a success, and Blinken passed on Fried's advice which was "that people should not really sell these futurist pictures since they will be worth big money in a few years. Claims Balla's hardest of all to come by - bought all she could lay her hands on - which wasn't much". Balla was particularly sought after by American museums at this time. Even Fried was amazed by the interest the show created. In a later letter, Blinken tells Estorick that Fried still had a fine Balla to sell and that Severini's "Festa a Montmartre" (Festival in Montmartre) was still available. Estorick did not buy either of these works, and a picture-buying syndicate between Blinken, Fried and Estorick, which Fried proposed, also came to nothing.

[37] Letter from Donald Blinken to Eric Estorick, 8 June 1953.

[38] Seven collectors lent works to a "Personal Choice" exhibition at Wakefield City Art Gallery in March-April 1953. The critic of the "Manchester Guardian" on 6 March 1953 singled out Eric Estorick and F. R. S. Yorke as the most interesting selections, and particularly Estorick's choice of Mario Sironi, Massimo Campigli and Marino Marini: "All provide evidence of the variety and vitality of the contemporary Italian school."

[39] Wakefield City Art Gallery, *Contemporary Italian Art* with

an introduction by Robert Melville, 3 April - 2 May 1954, thereafter touring to Liverpool, Walker Art Gallery (8 May - 5 June); Salford, City Art Gallery (12 June - 3 July); Scarborough, City Art Gallery (10 July - 7 August); Hull, Ferens Art Gallery (14 August - 11 September); Huddersfield, City Art Gallery (18 September - 14 October); Hatton Gallery, Newcastle-upon-Tyne (23 October - 20 November) and York, City Art Gallery, (27 November - 24 December). The same exhibition travelled to Belfast, Dublin and Limerick in Ireland, from January - March 1955. The catalogue contents varied slightly, the title pages were changed and there was another introduction, this time written by James White. Artists included in both exhibitions were: Renato Birolli, Umberto Boccioni, Nino Caffé, Massimo Campigli, Carlo Carrà, Bruno Caruso, Felice Casorati, Bruno Cassinari, Giorgio de Chirico, Emilio Greco, Mario Mafai, Giacomo Manzù, Marino Marini, Arturo Martini, Mlenkovitch, Amedeo Modigliani, Giorgio Morandi, Marcello Muccini, Antonio Music, Aldo Pagliacci, Beverley Pepper, Fausto Pirandello, Filippo de Pisis, Ottone Rosai, Guiditta Scalini, Gino Severini, Mario Sironi, Ardengo Soffici, Arturo Tosi, Mario Tozzi and Renzo Vespignani.

[40] He did not meet Carrà in person until 1956.

[41] *Il Milione. Bollettino della Galleria del Milione*, Nuova Serie 1, November 1952.

[42] See *Contemporary Italian Art* cit. note 39. Most works of art from this shipment appear in the Wakefield exhibition with the following catalogue numbers: Boccioni (2), Caffé (4), Campigli (6, 7), Pagliacci (76), Pirandello (79, 80), De Pisis (92), Severini (101-103, 106), Tozzi (133), Vespignani (134-136).

[43] See *Contemporary Italian Art* cit. note 39. Some works of art from this valuation list appear in the Wakefield exhibition with the following catalogue numbers: De Chirico (35, 32, 36, 33), Severini (104, 105), Soffici (131), Manzù (44), Marini (45, 46, 50).

[44] See *Contemporary Italian Art* cit. note 39. Purchases from Barbaroux appear in the Wakefield exhibition with the following catalogue numbers: Morandi (57, 58), De Pisis (94), Boccioni (3), Martini (51).

[45] A. C. S., *Twentieth Century Italian Art: A Comprehensive Review* in the "Manchester Guardian", 7 April 1954.

[46] "The Northern Whig and Belfast Post", 2 February 1955.

[47] Estorick always took the press very seriously. Cuttings were comprehensively kept of all his own writings and criticisms about his Stafford Cripps biographies. Press attention for this first regional tour was taken to heart by Estorick; reflected in his attempts to involve other collectors of Italian art for the Tate Gallery show in 1956. He also incorporated works by Afro and Guttuso in later showings of his Italian collection.

[48] In some cases this proved complicated when Italian works travelling in "Contemporary Italian Art" could not be made available at short notice. Sidney Janis had a small "Billiard Table" painting by Braque that he was offering in exchange for De Chirico's "La rivolta del saggio" (Revolt of the Sage) and a small "Interno metafisico" (Metaphysical Interior). The exchange did not happen.

[49] Estorick had to wait until "Arte italiana del xx secolo da collezioni americane", organised by the Museum of Modern Art in New York, was held at the Palazzo Reale in Milan in 1960. Here major paintings from Estorick's collection were seen alongside those of Peggy Guggenheim, Mr and Mrs Harry Lewis Winston Malbin, Nelson A. Rockefeller, Joseph Slifka and James Thrall Soby as well as public collections. The catalogue is a comprehensive record of American preferences in modern Italian art.

[50] Slifka was a multi-millionaire and Estorick helped him put together an important collection of Futurist works, including works by Balla, Carrà and Severini. In a letter to Campigli of 3 February 1958 Estorick said, "I have been responsible for the creation of the greatest Italian collection in the United States next to Nelson Rockefeller's which belongs to Mr Joseph Slifka. Under my encouragement, advice and direction he has put together a very formidable collection of twentieth century Italian art".

[51] When Estorick later wanted to exhibit this oil sketch there was an outcry, and it was thought to be a fake. The painting was withdrawn from Finarte's "Vendita pubblica all'asta di opere d'arte moderna", November 1961. Documents written by Carlo Carrà state the oil sketch was painted in 1920. In M. CARRÀ, *Carrà. Tutta l'opera pittorica. vol. II 1931-1950*, Milan 1968, p. 393, it is dated 1940. Estorick bought the sketch in good faith and maintained his belief that the oil sketch preceeded a finished larger version dated 1921 in the Mattioli Collection, Milan.

[52] Estorick states in his memoir, p. 79, that on one occasion in Venice he bought three works directly from him. This may explain the lack of documentation to several Severini works in his collection.

[53] *Ibid.*

[54] Most changes came with more contemporary artists: Caffé, Muccini, Mlenkovitz, Pagliacci and Pepper were omitted. Caruso was only represented by one pen drawing, while additions included Renato Guttuso, Leonardo Cremonini, Guiseppe Ajmone, Aldo Gentilini and Ennio Morlotti and the sculptor Giorgio di Giorgi, whose work was lent on consignment.

[55] It is remarkable that the Futurists have never found their way into any major public collection in Britain, but somehow the reviews of Estorick's exhibition make it clear that for many critics the Futurists did not accord with English taste.

[56] This time "Modern Italian Art from the Estorick Collection" travelled to London, Tate Gallery, 21 November - 19 December 1956; Plymouth, City Art Gallery (26 January - 16 February 1957); Birmingham, City Art Gallery (23 February - 16 March); Newcastle, Laing Art Gallery (23 March - 27 April); Cardiff, National Gallery of Wales (4 - 25 May).

[57] See National Gallery of Canada, "Modern Italian Art from the Estorick Collection" touring to Ontario, Hamilton Art Gallery, 7 - 28 January 1958; Ontario, London Public Library (7 - 28 February); Ottawa, National Gallery (7 - 30 March); Quebec, Le Musée de la Province (14 April - 4 May); Manitoba, Winnipeg Art Gallery (15 May - 15 June), and Saskatchewan, Regina and Norman Mackenzie Art Gallery (July - August).

[58] This final version of the Estorick collection of 108 works of art went to Amsterdam, Stedelijk Museum, 4 March - 4 April 1960; Eindhoven, Van Abbemuseum (9 April - 21 May); Vienna, Akademie der Bildenden Kunste (17 June - 25 July); Linz, Neue Galerie der Stadt (5 August - 4 September); Recklinghausen, Stadtische Kunsthalle (17 September - 16 October).

[59] Estorick and Burt Lancaster corresponded from the late 1950s into the 1960s, always over picture transactions. Relations between the two men were convivial and in a letter dated 9 April 1959 Lancaster invites him to visit at his home in Durango, Mexico. He suggests a visit to Mexico City to "find whatever interesting paintings there may be. John Huston tells me that a man by the name of Cuevas is, in his opinion, the finest of the new group of Mexican artists, but you can talk to him about that and I am sure he can give you lots of information..."

[60] Works that were sold include: Campigli, "The Boat", 1931; Carrà, "La stella", 1916; De Chirico, "Tower", 1921 and "Metaphysical Family", 1926; Mafai, "Bowl of Cherries"; Morandi, "Still Life with Shell", 1938; Severini, "Woman at the Window (Portrait of Mrs Paul Fort)", 1913 and "Basket with Oranges", 1917.

[61] Balla, "The Hand of the Violinist"; Boccioni, "Modern Idol"; Carrà, "Leaving the Theatre" and "Synthesis of a Café Concert"; Russolo, "Music"; Severini, "The Boulevard" and "Dancer (Ballerina + Sea)", 1913 and Soffici, "Decomposition of the Planes of a Lamp".

[62] ESTORICK, memoir cit., p. 4.

Futurism in Italian art collections

LIVIA VELANI
Director of the Twentieth Century Department, Galleria Nazionale d'Arte Moderna, Rome

I n his opening comments at the dedication of Emilio and Maria Jesi's well-known and much admired art collection, on the occasion of its donation to the Brera Museum, the renowned art critic, Gian Alberto dell'Acqua managed to capture that most subtle significance which is at the basis of all forms of collecting: "Whether large or small, a private art collection born from an authentic passion cannot be abstractly reduced to a simple sum of the works of which it is composed. Rather, it acts as a mirror reflecting the critical intelligence, affections, emotions, likes and dislikes of those who have assembled it, piece by piece, and lived with it in long, continuous contact".[1]

The fact that almost all the great Italian art collections, formed in the 1920s and 1930s, showed very little interest in Futurism was a definite sign of a fundamental hostility towards the avant-garde or, even more, an unconscious rejection of anything which broke rules and moved towards a new language of expression. Futurist works were in fact almost absent in the collections formed in the period just after the First World War. Dominant in these were Metaphysical paintings where the vein of surrealism, supported by a return to figurative design, was evidently more reassuring than the speeding vehicles of Futurism.

The best Italian collections of the period, from the Valdameri (containing the rare metaphysical "Still Life" (Natura morta) by Morandi, now in the Brera, which had passed from the Della Ragione Collection in Genoa to the Jesi Collection) to the Casella, the Della Ragione, the Rimoldi, the Cardazzo and the other very well known collections (those of Frua de Angelis, Gualino, Feroldi and Ventura), today largely dispersed, all contained predominantly figurative works by Italian artists and almost always achieved the same level of importance. The artists featured ranged

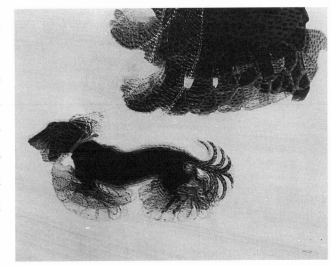

1. Giacomo Balla, "Dynamism of a Dog on a Leash", 1912, Albright-Knox Art Gallery, Buffalo.

from Rosai, Soffici and Morandi in central Italy, to Tosi, Carrà and Sironi in the north, to then move on with maximum openness towards artistic innovation to the French Impressionists and Fauves.

There was a particular predilection for Modigliani, the painter "of long necks". Placed in the category of "monsters" by Enrico Thovez, the critic from "La Stampa" in Turin who railed against his paintings in 1922[2], Modigliani became a "must" for Italian collectors of the era. Because of cultural implications which connected him to the old Italian tradition, from Simone Martini to Sandro Botticelli, and thanks also to the enormous influence exercised by Lionello Venturi's book, *Il gusto dei primitivi*, published in 1926, his artistic distortions came to represent the phenomenon of modern primitivism.

> I met Lionello Venturi in 1918. In the beginning, our relationship was marked by more than a little reciprocal mistrust... A whole world separated our ways of thinking and feeling... On the other hand, due to my own lack of knowledge, I was intimidated by his vast, deep, well-grounded culture and refined tastes, already containing sparks of modernism which shook and shattered my old-fashioned tastes... He... imperceptibly altered my artistic vision and merged it with my life. He helped me understand, without ever telling me, the illogical nature of a man who has a dynamic, fervent, restless life continually drawn towards whatever is new and daring, but yet who falls asleep among antique decorations and reconstructions of the past. He taught me to love art for art, beauty for beauty[3].

Riccardo Gualino clearly expressed the difficulties involved for him regarding general comprehension and openness towards the innovations of modern art in the still old-fashioned, cultural climate of Turin. Inspired by Venturi's idea for an international collection, Gualino assembled an important collection of works, including French Impressionists and a good seven paintings by Amedeo Modigliani, which, in their turn, inspired the young painters of the "Sei di Torino" group, particularly Francesco Menzio, Gigi Chessa and Felice Casorati, whose paintings were then also included in his collection. Giuseppe Marchiori, in his concise and attentive analysis in search of points of specific international interest in Italian art collecting, noted the extraordinary case of the sixteen Cézannes in Egisto Fabbri's Collection from 1899, which then grew to twenty-four during the exhibition in the French Pavilion at the Venice Biennale in 1920. "Egisto Fabbri was without doubt the first modern art collector in Italy. The first who did not assemble collections of nineteenth century daubs or fake masterpieces, noted only by the buying committees for public galleries"[4].

These famous Cézannes, along with those belonging to Carlo Loeser and Sforni, were legendary in Florence at the beginning of the century. Young artists, such as Morandi and Soffici, made pilgrimages to see them and based their initial studies on their cerebral quality of visual decomposition.

However, the popular view was still in the dark ages:

Fabbri was a pioneer who had no imitators for many years. His collection could have been the extraordinary nucleus for an Italian museum of modern art, from the Impressionists onwards. Instead, our galleries recorded artistic trends with works by Zorn, Sorolla, Zuloaga, Claus, Fortuny, Brangwyn, Cottet, Simon, Von Stück, Maljavin, Laermans, Mesdag, Lavery and Lazlo. They documented the history of the tastes of a society lagging half a century behind the reality of contemporary art[5].

Only at the end of the 1940s did a similar phenomenon occur on the Italian scene with Gianni Mattioli's Collection in Milan. This, along with the Jesi, Jucker and the earlier Borghi and Canavese Collections (the first in Brera, the others in Civiche Gallerie, Milan), finally created a real breakthrough in attitudes regarding Italian art collecting. With a perceptive selection of Futurist masterpieces, it at last began to give a proper perspective on the artistic resources of our century.

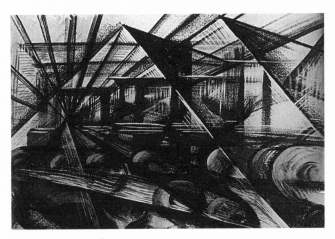

2. Giacomo Balla, "Dynamic Depths", c. 1913, tempera on paper 35 x 50 cm, Mattioli Collection, Milan.

Among these broad, and at times contradictory, investigations into the Italian avant-garde, the addition of Futurist works was an absolute innovation assimilating this concept of art collecting to the formation of those same interests in the Estorick Collection. Proof of one of the earliest collections to include Futurism is recorded in an account by Carrà[6] regarding a unique event which occurred at the 1912 exhibition at Walden's Der Sturm Gallery in Berlin. This was the unexpected and startling sale of twenty-four Futurist works to the collector Borchardt. (Among works sold by Carrà were "The Funeral of the Anarchist Galli" [I funerali dell'anarchico Galli], now in the New York Museum of Modern Art, a gift from Lilie P. Bliss Bequest, and "The Swimmers" [Le nuotatrici], now at the Carnegie Institute of Art in Pittsburgh). Walden, for his part, purchased several Severinis among which was the famous "Dance of the Pan Pan at the Monico" (La danza del Pan Pan al Monico), painted between 1910 and 1912 and since lost. On the same occasion, Boccioni sold "Modern Idol" to Borchardt, which then came into the Estorick Collection (cat. 3) after having gone from Basel to the Marlborough Gallery in London.

As Balla's daughters explained to me when specifically asked about the subject, sales at the time were very scarce. In fact, having lived since they were small in a sort of symbiosis with the fate of their father (who had become an avant-garde artist at forty-years-old), the news that Marinetti had sold one of their father's Futurist paintings was remembered by the family as a

rare event. Marinetti, the "press agent" of the group, took a percentage but the amount would certainly not have been very much. Carrà recorded the prices: 11,650 marks were paid for the group of twenty-four works. In the list of amounts for each of his nine paintings, the highest was fetched by "The Funeral of the Anarchist Galli" at 2,000 marks.

An exceptional work by Balla is the painting in pastels "Automobile + Noise" (Automobile + Rumore), property at the time of Theo van Doesburg, now in the Peggy Guggenheim Collection in Venice. This was a gift from the artist to Van Doesburg when he visited Balla's studio in Rome and was included in his collection along with the painting by Gino Severini "Dancer + Sea" (Ballerina + Mare) which had been acquired in the same way.

"Rhythms of the Bow", first title of "The Hand of the Violinist" (Ritmi d'archetto [La mano del violinista]), now in the Estorick Collection (cat. 1), was painted by Balla in Düsseldorf at the Löwenstein residence where he was a guest in 1912 and entertained himself by listening to the head of the house play the violin. This painting was known to have been a gift from the artist to that famous, indefatigable, guiding spirit of the Futurist *serate* in Milan, the Marchesa Casati, for whom Balla had also painted two portraits. One of these is among his most entertaining *complessi plastici* (plastic complexes), constructed of coloured wood with a pulsating heart of mica. The Marchesa Casati possessed several other masterpieces given to her as gifts by the various artists. This was also true later for another artistic muse in Milan, Margherita Sarfatti, champion of the "Novecento" movement. In her property was the magnificent oil painting by Umberto Boccioni, "Anti-graceful" (Antigrazioso); exhibited in 1912 in Rotterdam, it melded Cubist decomposition with the whirlwind of movement in Futurism. A preliminary study for this important work (ink on paper, 155 x 105 mm) is in the Gianni Mattioli Collection.

The 1912 work, "The 'Galleria' in Milan" (La "Galleria" di Milano), by Carrà was shown in the Futurist exhibitions in Rome, Rotterdam and Florence in 1913 and published in Boccioni's book, *Pittura scultura futuriste*, in March 1914. It was acquired that same year by Alberto Magnelli, for an uncle who was a collector, to help Carrà who needed money in order to extend his stay in Paris. He was paid 655 francs and said later, "I remember when I was painting this, I was so completely fascinated by the subject and the basic concepts which guided me, that for a while I could not have painted anything else"[7].

Carrà's "Leaving the Theatre" (Uscita dal teatro), now in the Estorick Collection (cat. 20), along with "Train Running by Night" (Treno in corsa nella notte) by Luigi Russolo, now lost, were both acquired by Max Rothschild at the Sackville Gallery exhibition in London, March 1912. In the Herbert Rothschild Collection[8], among works by Balla, Boccioni, Carrà and Severini, now donated to the New York Museum of Modern Art, the 1911 Boccioni masterpiece "The Laugh" (La risata), also originally from the Borchardt Collection, and his study in ink, "The Farewells:

Those Who Stay" (Gli addii: quelli che restano), done for Herwarth Walden's magazine "Der Sturm", stand out. As promoter of the first and second periods of Futurism, Marinetti kept a lot of works himself in the period after the World War, just as Mario Broglio did for the "Valori Plastici" group in the 1920s. The list shows that, along with works by minor painters such as Giannattasio, Lega and Marasco, there were also several fundamental masterpieces by the legendary masters in his collection. These included one of Prampolini's first multimedia compositions, the Futurist composite, "Portrait of Marinetti" (Ritratto di Marinetti, 1933-1934), and one of Balla's most important paintings from his interventionist period, "Patriotic Song on the Altar of the Homeland" (Canto patriottico sull'altare della

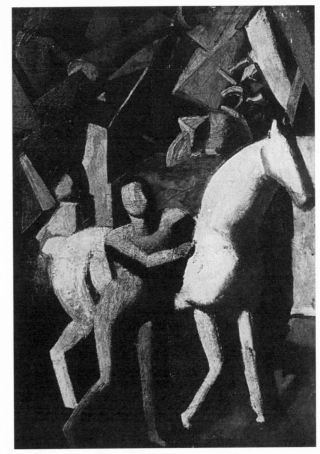

3. Mario Sironi, "The White Horse", c. 1919, oil on canvas 79 x 59 cm, Mattioli Collection, Milan.

patria), of 1915, recently acquired by Galleria Nazionale d'Arte Moderna in Rome. "Decorative Motif with Patriotic Crowds and Landscape" (Motivo decorativo con folle patriottiche e paesaggio), also of 1915, later went from the Marinetti Collection to the famous Winston-Malbin Collection. We might say that this last collection had cornered the market in Futurist works during the period after the Second World War, since their choices were dealt with directly in Italy through Marinetti and Severini.

The very exceptional acquisition in 1938 of "Dynamism of a Dog on a Leash" (fig. 1)[9] was made on a visit to the artist's studio in Rome by A. Gonger Goodyear. In 1929, Goodyear, vice president of the Buffalo Fine Arts Academy, was to be one of the promoters for the founding of the New York Museum of Modern Art and its president for ten years. In 1934, this Balla masterpiece, painted just a few months before "The Hand of the Violinist" (Ritmi d'archetto), was exhibited in a collective show for the fifth anniversary of the founding of the New York Museum[10].

This was the prelude to a wave of acquisitions of Futurist works begun by the Americans in the years after the Second World War. "The Futurist idea itself of expressing dynamic motion in space, inspired by the industry of the United States in the early twentieth century, has engaged our interest"[11], declared Lydia Winston in remembering the specific interest which had guided

the numerous acquisitions of Futurist works, particularly by Boccioni, made by her and her husband, which underlined once again the artistic affinity felt with American Abstract painting: "Futurism, now part of history, should be basic and understandable here in America"[12]. Numbered in the Winston-Malbin Collection was also a gouache by Balla for "Mercury Passing before the Sun" (Mercurio passa davanti al sole) of 1914, which came from the Mattioli Collection. A certain resistance in Italy, due in part to the association of Futurism with Fascism, caused us to lag behind; even though one of the American acquisitions for the New York Museum of Modern Art was actually decided at the V Rassegna Nazionale di Arti Figurative of 1947-1948, the first recurrence of the Quadriennale held in its temporary headquarters at the National Gallery in Rome. "Speed of the Automobile" (Velocità d'automobile) by Balla was shown there in the "Italian Futurist Movement" section alongside other works by him and by Russolo, Severini, Prampolini and Sironi. In Italy, interest in Futurism returned in the fifties, particularly through the works of young abstract artists who rediscovered in Balla the true inventor of the Italian avant-garde, and were fascinated by the creative versatility of his mind. This interest was so great that even in Rome a sort of movement in collecting started with Pietro Campilli who felt the new change in the air and, within a very few years, expanded his collection with more than thirty works by Balla, along with works by Sironi, Severini and Boccioni.

In 1951 the members of the "Gruppo Origine" (Ballocco, Burri, Capogrossi, Colla) dedicated an exhibition, "Omaggio a Giacomo Balla futurista", to the maestro years after the last Futurist exhibition in 1930. On display were twenty Futurist works, painted between 1913 and 1929, which had been discovered in a corner of the studio where Balla himself, alone and ignored at the time, had hidden them. From this point on, attention turned to these Italian masters, now considered as a point of reference and an opening towards new horizons of artistic innovation. The works of Balla, along with those of the Futurist and Abstract artists of the 1930s were once again presented in important, historical, international exhibitions. Several Futurist paintings by Balla were shown at the Venice Biennale in 1948 in the section of the Peggy Guggenheim Collection, curator Giulio Carlo Argan, including the pastel "Automobile + Noise" (Automobile + Rumore) which had belonged to Theo van Doesburg.

In 1949 the New York Museum of Modern Art dedicated a major exhibition, entitled "XX Century Italian Art", to the previous forty years of Italian art. The conspicuous presence in this exhibition of nearly fifty Italian artists and two hundred and fifty works, chosen by James T. Soby and Alfred H. Barr Jrn., was a measure of the high level of international appreciation attained by Italian art in America. In the section on Futurism, which, along with the Metaphysical School, represented the Italian avant-garde, three of the six Futurist works displayed by

Balla were already in American collections: "Speed of the Automobile" (Velocità d'automobile), already acquired for the Galleria Nazionale d'Arte Moderna in Rome; "Studies of Swifts" (Studi di rondini) from a private collection, and the major painting on the theme of swifts' flight, "Swifts: Paths of movement + Dynamic Sequences" (Linee andamentali + successioni dinamiche), which was soon to become part of the Museum of Modern Art collection. The exhibition which followed in 1950 at the Musée d'Art Moderne in Paris caused the noted French critic, Christian Zervos, to dedicate an edition of "Cahiers d'Art" to it the same year, entitled *Un demi-siècle d'art italienne*, with Balla's "Patriotic Song in the Piazza di Siena" (Canto patriottico in Piazza di Siena) on the cover. The section on Futurism opened with a foreword by Benedetta Marinetti. Particular interest was once again given to the works by Balla in the exhibition "Futurismo e pittura metafisica" at the Kunsthaus in Zurich, in the winter of 1949. Balla said at the time, "Today, I'm very happy but also a bit stunned to have pulled out old Futurist canvases I had put away twenty years ago. I thought they were things that had only to do with my private art, but instead they are also a part of history..."[13]

Balla died in 1958 but lived long enough to see his name included among the pioneers of Abstract art in a group show held in 1951 at the Bompiani Gallery in Milan. His works and those of his Futurist colleagues, Depero, Fillia, Severini and Prampolini, were exhibited there alongside those by Licini, Magnelli, Radice, Reggiani, Badiali and Fontana, the leading avant-garde names in Italian Abstract painting between the two world wars. That same year his paintings were included, together with works by the great masters such as Arp, Archipenko, Braque and Kandinsky, in a group exhibition organised by the legendary Galleria del Milione in Milan. As a conclusion to this survey on overseas interest in the Italian avant-garde, which in these years was becoming ever more autonomous in character, we need only refer to the Soby exhibition, "Italian Art of the 20th Century in American Collections", re-proposed in Europe in 1960, in order to demonstrate how diffuse Italian works were in American collections. A little later, in 1961, Joshua C. Taylor organised an important historical exhibition entitled "Futurism", preceded in 1960 by the XXX Biennale of Venice, which dedicated an entire section to the "Mostra storica del futurismo".

Returning now to the Mattioli Collection which, for the importance of its selections, offers one of the most interesting views of Futurist, Metaphysical and

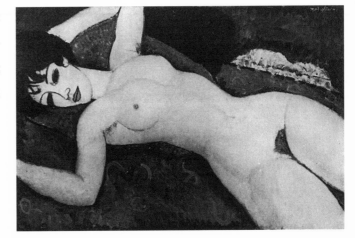

4. Amedeo Modigliani, "Reclining Nude",
1917-1918, oil on canvas 60 x 92 cm,
Mattioli Collection, Milan.

5. Amedeo Modigliani, «Portrait of the Painter Frank Haviland», c. 1914. Mattioli Collection, Milan.

"Novecento" works, it is necessary to emphasize how, in its rich, up-to-date content and original outlook on contemporary art, it can be considered as being similar, if not superior, to the Estorick Collection.

From the point of view of content, the Estorick Collection was at one time much richer in both Italian artists and works than it is now. For example, several historical sources mention important works by Sironi, among them the oil and tempera painting "Figure" (Figura), various charcoal and ink drawings and the beautiful tempera and collage work entitled "Paper Apocalypse" (Apocalisse cartacea)[14].

Originating from a real passion for art, the Mattioli Collection was cultivated over time with persistence, patience and careful selection, which, as the collector himself says, sprang from "among the works of the artists of my generation, or with those still living"[15]. The "Archeologists" (Archeologi) of 1927 by De Chirico, along with works by Carrà, Campigli, Morandi, Sironi, Funi, Martini, Manzù, Marini and a group of Futurists were already in his collection when he had the good fortune to discover the patiently assembled Feroldi Collection in Brescia, which had a particular predilection for Metaphysical painting[16]:

> I must admit that luck was with me on more than one occasion and very much so on that day, several years ago, when I happened upon a beautiful group of works which, in spite of the fact I didn't own them, I had learned to love a long time ago. Among these were Amedeo Modigliani's "Nudo rosa" ["Pink Nude"], Giorgio de Chirico's "Le muse inquietanti" ["Disquieting Muses"] and ."Ettore e Andromaca" ["Hector and Andromache"], Carlo Carrà's "L'amante dell'ingegnere' ["The Engineer's Mistress"], and several "Nature morte" ["Still Lifes"] by Morandi[17].

Gianni Mattioli tells of his passion for art collecting, which started before the war when he was still very young but did not have enough money to buy paintings and instead cut out pictures from magazines to save in albums: "I liked modern paintings (these were the years of Futurism and Metaphysical painting), and gazed at them, rare at the time, in exhibitions and the windows of Milanese galleries"[18].

His first work, a "colour print reproduction of a painting by the Blaue Reiter"[19], was given to him by the clerks in a shop which sold German typewriters, where it had been displayed. His first

acquisition soon followed which happened to be a Boccioni, "two small sheets of paper which I jealously took home," discovered in the 'Bottega di Poesia' in via Monte Napoleone, managed at the time by Emanuela Castelbarco. "Clipping by clipping, drawing by drawing, years passed and I began bringing home the occasional painting. I loved to change their places, from one wall to another, in the pleasure of living with them in a state of continual surprise"[20].

It is important to note here that in those years, Mattioli did not yet give any particular importance in his collection to Futurist works, citing them only marginally, while he praised Modigliani's "Pink Nude" (Nudo rosa) as "the work I still prefer even now"[21]. He remembers the acquisition, in 1949, of a rare Fauve work, the "Portrait of Frank Havilland" (Ritratto di Frank Havilland). From the register of masterpieces in his collection, several real gems stand out such as Boccioni's great oil painting of 1912, "Matter" (Materia) and the only oil study for the "The City Rises" (Città che sale). This famous picture by Boccioni was acquired in the period after the war by the New York Museum of Modern Art. Estorick had a tempera on cardboard of it which came from the collection of the noted literary critic and editor of the "Corriere della Sera", Antonio Giuseppe Borgese. Once more from the Marinetti Collection come two fundamental works by Balla, the speed of the automobile in monochrome, "Dynamic Depths" (Profondità dinamiche) (fig. 2, tempera on paper, 35 x 50 cm) and a "Study for 'Woodcutting'" (Bozzetto per il "Taglio del bosco", oil on paper mounted on canvas, 50 x 70 cm), both shown at the exhibition of avant-garde art, "Renaissance du XX Siècle", held at the Stedelijk Museum in Amsterdam in 1958[22]. They were shown along with other fundamental works by Balla such as "Mercury Passing before the Sun" (Mercurio passa davanti al sole, 1914, tempera on canvas on board, 123 x 100 cm) and the 1913 tempera on canvas "Swifts: Paths of Movement + Dynamic Sequences" (Linee andamentali + successioni dinamiche), a contemporary to the one in the New York Museum of Modern Art.

Mattioli also acquired from the Magnelli Collection "La 'Galleria' di Milano" by Carrà, which had been bought in Paris in 1914, and enlarged his Futurist collection with early works by Soffici, Sironi and even Rosai, from that brief period when they were followers of the movement. Included in this last group are various figurative works and, previously from the Feroldi Collection, Sironi's "The White Horse" (Il cavallo bianco) (fig. 3), of about 1919, in which the overall Metaphysical style anticipates his later plastic developments in the "Novecento" group.

In tacit dispute with the public institutions, collectors such as the Jesi, the Feroldi, the Della Ragione and a very few others, despite the disinterest or mistrust which surrounded them, became farsighted upholders of a "contemporary museum aligned with the apex of a culture in evolution"... It is also important to reiterate how these collections, in being a product not yet of calculated interest but rather of intelligence and passion, took advantage of the opportunities lost by our museums[23].

In fact, if not for the donations of these collections, as happened with the Della Ragione Collection in Genoa, open to the public in Florence, the Vismara and Boschi Collections in Milan and, in the same city, the Jesi and more recently the Jucker Collections, Italian museums would have otherwise found themselves with no informed documentation of the culture of their country. On this point it is useful to bear in mind as an example the struggle and effort involved in the project, proposed in the 1960s by the Galleria Nazionale d'Arte Moderna in Rome, to acquire works by internationally famous artists on the occasion of the sale of the important Thompson Collection presented at the Galleria Civica in Turin in 1961. A commission, made up of Rodolfo Pallucchini, Anna Maria Brizio, Cesare Brandi, Giulio Carlo Argan and Palma Bucarelli, proposed purchases for the Galleria Nazionale of paintings by Klee, Kandinsky, Wols, Gorky and even Bacon at ridiculously low prices, but only after a long and difficult correspondence, did this entire project end in the acquisition of a Degas pastel and a Cézanne water colour. Only in time would they be followed by a work by Van Gogh, one by Monet, two by Modigliani (by whom drawings from the Brillouin Collection were donated in 1958) and two by Moore. In a museum where an acquisition of a work by a foreign artist went back to 1911, with "The Three Ages" by Gustav Klimt (not to speak of the avant-garde of Futurism and Metaphysical painting which are completely absent), the director at the time, Palma Bucarelli, also proposed the acquisition of works by Picasso, Bonnard, Soutine, Derain, Matisse and Braque. Yet all this was to no avail, given the already high prices and the continuous lack of funds, or perhaps foresight, on the part of a bureaucratic machine frightened by so much boldness, seeing that immediately afterwards a parliamentary investigation was held regarding the acquisitions made.

Translated by David Henderson

42

[1] G. A. Dell'Acqua, *La collezione Jesi*, Milan 1981, p. 9.

[2] G. Marchiori, *La pittura straniera nelle collezioni italiane*, Turin 1960, n. p.

[3] R. Gualino, *Frammenti di vita*, Turin 1931, pp. 141-142.

[4] Marchiori, *La pittura straniera* cit., n. p.

[5] *Ibid.*

[6] C. Carrà, *La mia vita*, Milan 1945, pp. 165-167

[7] *Ibid.*, p. 189.

[8] *Herbert and Nanette Rothschild Collection*, Pembroke College, Brown University, 1966.

[9] S. A. Nash, *Painting and Sculpture from Antiquity to 1942*, Albright-Knox Art Gallery, Buffalo 1942, p. 328.

[10] *Modern Works of Art*, "Fifth Anniversary Exhibition", Museum of Modern Art, New York 1934, p. 25.

[11] L. Winston in *Collecting Modern Art*, travelling exhibition, Detroit 1958, p. 15.

[12] *Ibid.*

[13] *Giacomo Balla*, Galleria Nazionale d'Arte Moderna, Roma dicembre 1971 - febbraio 1972, p. 116.

[14] *Archivi del Futurismo*, vol. II, 1962, pp. 392-393.

[15] G. Mattioli, *Come ho formato la mia collezione*, in *La Biennale*, No. 3, January 1951, pp. 25-26.

[16] *Ibid.*

[17] *Ibid.*

[18] *Ibid.*

[19] *Ibid.*

[20] *Ibid.*

[21] *Ibid.*

[22] *Masters of Modern Art*, Park Avenue Olivetti, New York, 1969.

[23] Dell'Acqua, *La collezione Jesi* cit., p. 10.

Colour plates

I. *Giacomo Balla*
"THE HAND OF THE VIOLINIST", 1912
OIL ON CANVAS 56 x 78.3 CM (FRAMED)
(cat. 1)

II. *Umberto Boccioni*
Study for "The City Rises", 1910
TEMPERA ON PAPER LAID DOWN ON BOARD
17.5 x 30.5 cm
(cat. 4)

III. *Umberto Boccioni*
"MODERN IDOL", 1911
OIL ON PANEL 60 X 58.4 CM
(cat. 3)

IV. *Massimo Campigli*
"IL BELVEDERE", 1930
OIL ON CANVAS 100 x 81 CM
(cat. 10)

V. *Carlo Carrà*

"Leaving the Theatre", 1910-1911

Oil on canvas 69 x 91 cm

(cat. 20)

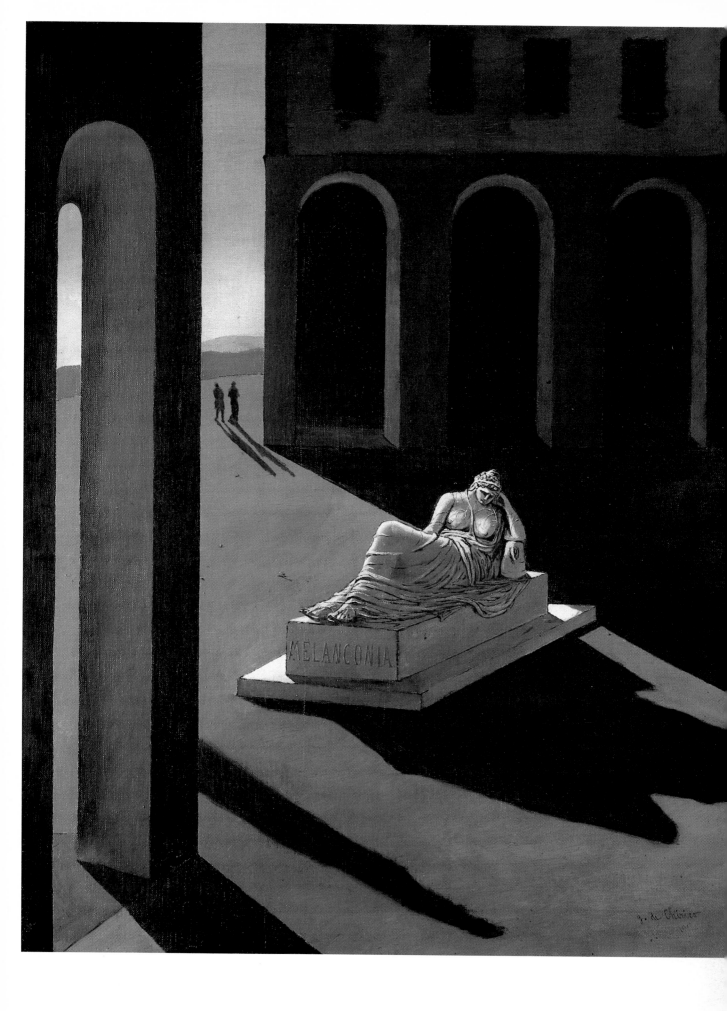

VI. *Giorgio de Chirico*
"MELANCONIA", 1912
OIL ON CANVAS 78.5 x 63.5 CM
(cat. 24)

VII. *Giorgio de Chirico*
"The Revolt of the Sage", 1916
oil on canvas 66.5 x 53 cm
(cat. 23)

VIII. *Renato Guttuso*
"Death of a Hero", 1953
OIL ON CANVAS 88 x 103 CM
(cat. 27)

IX. *Giacomo Manzù*
"BUST OF A WOMAN", 1952
BRONZE WITH BROWN / GREEN PATINA
HEIGHT 66 CM
(cat. 29)

X. *Marino Marini*
"POMONA", 1943
BRONZE; TRACES OF SURFACE COLOURING
HEIGHT 43 CM
(cat. 32)

XI. *Marino Marini*
"Quadriga", 1942
BRONZE 51 x 52 CM
(cat. 31)

XII. *Amedeo Modigliani*
"Dr. François Brabander", 1918
OIL ON CANVAS 46 x 38 CM
(cat. 34)

XIII. *Zoran Music*
"Horses and Landscape", 1951
oil on canvas 81 x 100 cm
(cat. 48)

XIV. *Medardo Rosso*
"IMPRESSIONS OF THE BOULEVARD:
WOMAN WITH A VEIL", 1893
WAX 60 X 59 X 25 CM
(cat. 51)

XV. *Luigi Russolo*
"Music", 1911
OIL ON CANVAS 220 X 140 CM
(cat. 52)

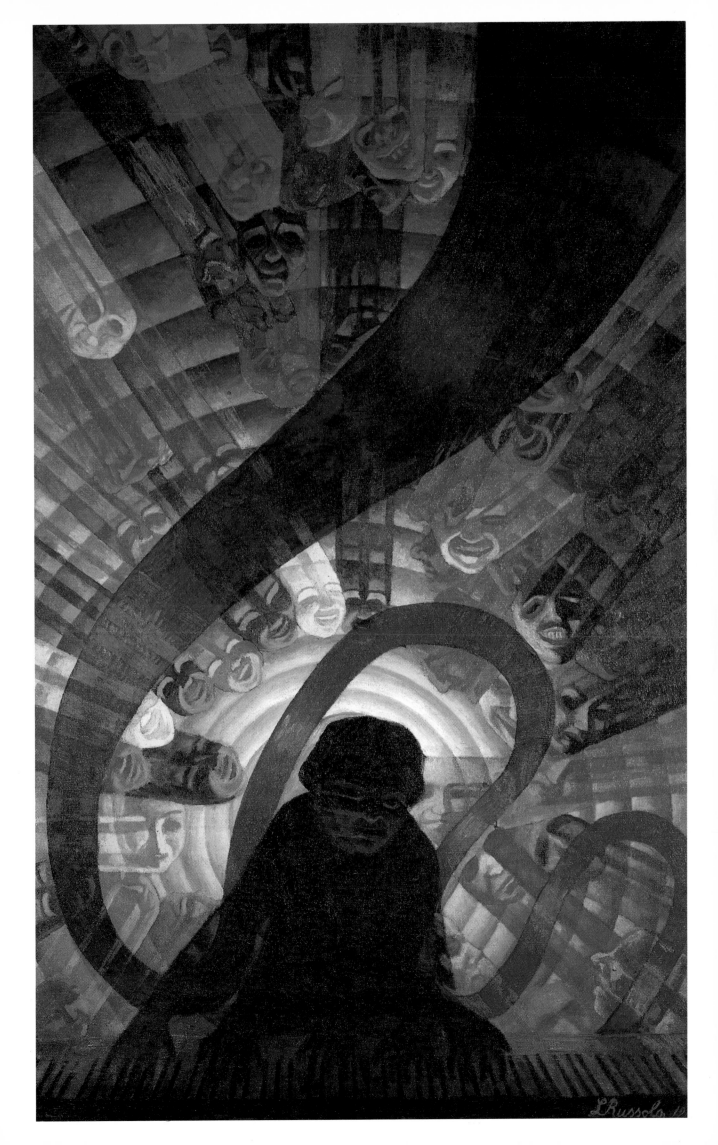

XVI. *Gino Severini*

"DANCER (BALLERINA + SEA)", 1913

OIL, GOUACHE, BLACK WASH AND PASTEL ON BOARD

75.5 X 50.5 CM

(cat. 57)

XVII. *Gino Severini*
"The Boulevard", 1910-1911
OIL ON CANVAS 63.5 x 91.5 CM
(cat. 56)

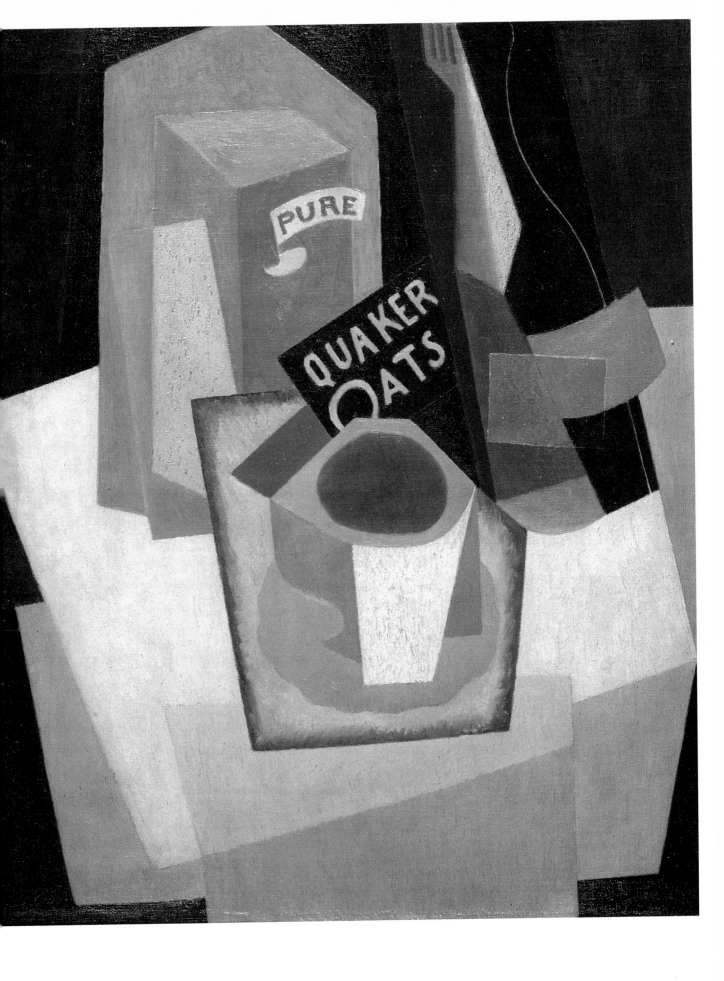

XVIII. *Gino Severini*
"Quaker Oats - Cubist Still Life", 1917
OIL ON CANVAS 62 x 51 CM
(cat. 54)

XIX. *Mario Sironi*
"THE METAPHYSICAL ROBOT ARANT
(CYLINDRICAL FIGURE WITH ANIMAL)", 1915
PEN AND GOUACHE ON PAPER 28 X 21.5 CM
(cat. 59)

xx. *Ardengo Soffici*
"Decomposition of the Planes of a Lamp", 1912-1913
OIL ON PANEL 45 x 34 CM
(cat. 78)

Catalogue

ALEXANDRA NOBLE WITH HILARY CANAVAN

1.

2.

1.

GIACOMO BALLA

"The Hand of the Violinist", 1912

(La mano del violinista - Ritmi d'archetto)

signed lower centre BALLA

oil on canvas 56 x 78.3 cm (framed)

Italian customs stamp dated 29.8.'13 affixed to

original frame.

Provenance: purchased from Alex Reid & Lefevre, London in 1954; previously Casati Collection.

Also known as Rhythms of the Bow; The Rhythm of the Violinist.

In the autumn of 1912 Balla made the second of two visits to Düsseldorf to complete a commission of interior wall decorations for his former pupil Grete Löwenstein and her husband Arthur. Letters Balla wrote to his family in Rome indicate that he had already begun studies for this picture by 18 November 1912. Balla used Arthur Löwenstein, a lawyer and amateur violinist, as his subject, or more pre-

cisely, the movements of his hand as he played his violin. Despite Grete's entreaties, Balla took the painting back to Italy and exhibited it in his first public showing as a Futurist at the Teatro Costanzi, Rome, in February 1913. Sadly, other works made for the commission were destroyed during the Second World War. By 1912, Boccioni, Carrà and Russolo had already attempted the portrayal of successive phases of movement. Using a running horse as their subject they each attempted to fulfil the assertion: "Moving objects multiply themselves, become deformed, follow each other in succession, like vibrations in the space through which we travel. Thus, a running horse has not four legs, but twenty and their movements are triangular" (*Futurist Painting. Technical Manifesto*, April 1910). Balla's initial experiments resulted in "Dynamism of a Dog on a Leash" (Albright-Knox Art Gallery, Buffalo), featuring the movement of a scurrying daschund and the feet of its owner, and "Girl Running on a Balcony" (Civica Galleria d'Arte Moderna, Milan). Balla adapted his Divisionist application of paint to reveal a semi-transparent sweep of motion. The measured layered strokes of alternating colour blur together to give the impression of gliding movement. The black and white trapezoidal frame was constructed by the artist and may have been designed to suit the painting's intended surroundings at the Löwenstein home. It is an early example of Balla's creative approach to framing; in subsequent years he often tailor-made frames to accentuate a work's graphic impact and sometimes treated frames as an extension of the picture plane, continuing a stroke of paint from the canvas onto the frame itself. Balla's studies of the successive phases of movement, of 1912 and later, indicate careful consideration of the photo-dynamism of Anton Giulio Bragaglia and the chronophotography of Etienne-Jules Marey. Bragaglia's blurred time-delayed exposures capturing human gestural motion (1911-1912) were images with which Balla was familiar. With the aid of a 'photographic gun' Marey took a series of photographs of humans and animals in rapid succession, enabling a deconstruction of isolated movements in their component stages. Balla was acquainted with these scientific studies which he would have seen at the Exposition Universelle (1900) and in the many Italian journals which published Marey's studies.

Two preparatory studies exist for this work in private collections, but reveal little of the technical precision of the finished painting. Concomitant with Balla's creation of "The Hand of the Violinist" were his pioneering geometric colour studies, "Iridescent Compenetrations", some of the first non-objective art in Europe.

2.

GIACOMO BALLA

"Speeding Automobile", 1913

(Automobile in corsa)

signed and dated lower right *FUTURBALLA 1913*

coloured crayons and pencil on paper

25.5 x 29 cm

Provenance: purchased directly from the studio of Giacomo Balla in 1956 (?).

Although titled "Speeding Automobile" this drawing is close in composition to "Ritmo + velocità" (1913), pastel on paper, 27.5 x 42.5 cm, which forms part of the Luce and Elica Balla gift to the Galleria Nazionale d'Arte Moderna, Rome, and "Velocità astratta - l'auto è passata" (1913) in *Giacamo Balla*, Galleria Civica d'Arte Moderna, Torino 1963, cat. 116. Balla's series "Lines of Speed" (Linee di velocità) preoccupied him almost exclusively from late 1913 and throughout 1914.

3.

UMBERTO BOCCIONI

"Modern Idol", 1911

(Idolo moderno)

signed and dated lower left *U Boccioni 1911*

oil on panel 60 x 58.4 cm

Provenance: purchased from the Marlborough Gallery, London, in 1955; previously private collection, Basel; Nell Walden, Switzerland; Borchardt Collection, Berlin.

Until 1911 most of the portraits of women by Boccioni were of his mother, his sister or those connected with his family circle (see cat. 5). Only in "Mourning" of 1910 (private collection) is there a precursor to "Modern Idol"; the earlier painting shows old crones with garishly painted features in paroxyms of grief. The subject of "Modern Idol" is an urban prostitute, wearing a hat overweighted with fruit and flowers, illuminated by slashes of yellow light. The gaze of the prostitute immediately arrests and confronts the viewer. The colours are lurid. To understand the shift in Boccioni's treatment of female subject matter it is important to read *Manifesto of Futurist Painters* (February 1910) and *Futurist Painting. Technical Manifesto* (April 1910). The first is instructive in telling us what Futurist painters opposed:

1. Destroy the cult of the past, the obsession with... academic formalism. 2. Totally invalidate all kinds of imitation. 3. Elevate all attempts at originality, however daring, however violent. 4. Bear bravely and proudly the smear of 'madness' with which they try to gag all imitators... 6. Rebel against the tyranny of words: 'harmony' and 'good taste'... 7. Sweep the whole field of art clean of all themes and subjects which have been used in the past. 8. Support and glory in our day-to-day world...

The second for what they proposed:

... to paint a human figure you must not paint it; you must render the whole of its surrounding atmosphere... How is it possible still to see the human face as pink, now that our life, redoubled by noctambulism, has multiplied our perceptions as colourists? The human face is yellow, red, green, blue, violet...

"Modern Idol" is a powerful example of Boccioni's search for new subjects and by manipulating Divisionist techniques he presents us with one interpretation of the new Futurist agenda. In the first Futurist exhibitions of 1912, "Modern Idol" was described in the catalogue as "light effects on the face of a woman". At the Berlin showing in the Sturm Gallery it was sold into the Borchardt Collection. Two preparatory drawings exist. (See M. Calvesi & E. Coen, *Boccioni, L'opera completa*, Milan 1993, cats. 710 - 711).

3.

4.

4.

UMBERTO BOCCIONI

Study for "The City Rises", 1910

(Study for "La città che sale")

signed and inscribed lower left

A G Borgese U Boccioni

tempera on paper laid down on board

17.5 x 30.5 cm

Provenance: purchased from the Galleria del Milione, Milan, in 1957; previously in the Milanese collections of Riccardo Jucker, Romeo Toninelli, A. G. Borgese.

One of a series of studies for "The City Rises", oil on canvas, 199.3 x 301 cm, Museum of Modern Art, New York (Mrs Simon Guggenheim Fund 1951).

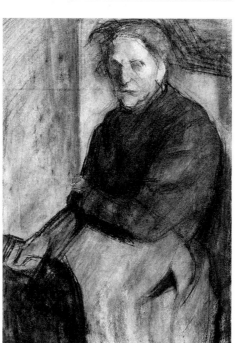

5.

5.

UMBERTO BOCCIONI

"Seated Woman (Artist's Mother)", 1907

(Donna seduta - La madre dell'artista)

signed lower right *Boccioni*

charcoal and chalk on paper 48.2 x 33.5 cm

Provenance: purchased from Vittorio E. Barbaroux, Milan, in 1956.

6.

UMBERTO BOCCIONI

Study for "Empty and Full Abstracts of a Head", 1912

(Study for "Vuoti e pieni astratti di una testa")

signed lower right *Boccioni*

pen, black wash and pencil on paper

56.5 x 44.7 cm

Provenance: purchased from the Galleria del Milione, Milan, in 1957.

This is one of two known preparatory studies for a sculpture in plaster destroyed after Boccioni's death. The other pencil drawing was owned by the Estoricks until at least 1983 but its present whereabouts are unknown. (See M. Calvesi & E. Coen, *Boccioni, L'opera completa*, Milan 1993, cats. 775-777).

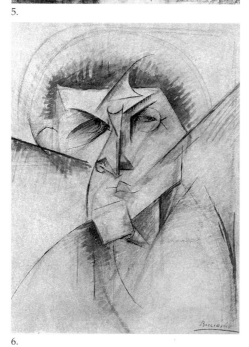

6.

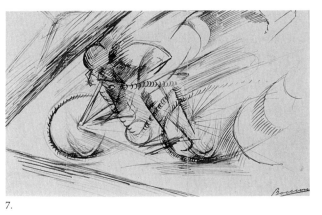

7.

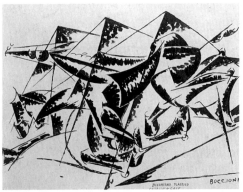

8.

9.

7.

UMBERTO BOCCIONI

"Dynamism of a cyclist", 1913

(Dinamismo di un ciclista)

signed lower right *Boccioni*

pen and black ink on paper 18 x 30 cm

Provenance: purchased late in 1956 or early 1957; source presently unknown.

The drawing (one of ten studies for *Dinamismo di un ciclista* 1913, oil on canvas 70 x 90 cm, private collection, Milan) makes its first appearance in an Estorick Collection exhibition: *Italienische Kunst im XX Jahrhundert,* Akademie der Kunst, Berlin, 21 September - 27 October 1957, cat. 19.

8.

UMBERTO BOCCIONI

"Plastic Dynamism: Horse + Houses", 1914

(Dinamismo plastico: cavallo + case)

signed lower right *Boccioni*

inscribed *Dinamismo plastico cavallo + case*

pen and ink on paper 33.1 x 42.6 cm

Provenance: purchased from Benedetta Marinetti in 1950.

This drawing is one of the most direct studies for the mixed media sculpture "Dinamismo di un cavallo in corsa + case" 1914 - 1915, gouache, oil, wood, cardboard, copper and coated iron 112.9 x 115 cm (see *Umberto Boccioni, dinamismo di un cavallo in corsa + case*, Peggy Guggenheim Collection, Venice 1996).

9.

UMBERTO BOCCIONI

Drawing after "States of Mind:

The Farewells", 1912

(Drawing after "Stati d'animo: gli addii")

black ink and wash on paper 33.5 x 44.5cm

Provenance: purchased from Marlborough Fine Art, London in 1955; previously private collection Switzerland; Nell Walden Collection.

One of several drawings executed after the completion of the oil painting "Gli addii - Stati d'animo II", 71.2 x 94.2 cm, Museum of Modern Art, New York, gift of N. A. Rockefeller. (See M. Calvesi & E. Coen, *Boccioni, L'opera completa*, Milan 1993, cats. 723, 730 & 736.)

10.

10.

MASSIMO CAMPIGLI

"Il Belvedere", 1930

signed and dated lower right

MASSIMO CAMPIGLI 1930

oil on canvas 100 x 81 cm

Provenance: purchased from Dr. Francesco Anfuso, Rome in 1953; previously Pierre Chareau, Paris.

11.

MASSIMO CAMPIGLI

"The Painter", 1932

(Il pittore)

signed lower left *M CAMPIGLI 1932*

monotype 27 x 25 cm

Provenance: purchased from Campigli's first English exhibition held at St. George's Gallery, London, June - July 1949.

11.

12.

MASSIMO CAMPIGLI

"Weeping is Not Allowed", 1944

(Non è lecito il pianto)

signed and dated lower right *Campigli 44*

and inscribed *prova* lower left

lithograph 15.5 x 23 cm

Provenance: purchased from Campigli's St. George's Gallery, London exhibition in 1949.

The lithograph has always been called "Five Women Playing" by Estorick, but is No. VIII of XII lithographs made by Campigli for *Liriche di Saffo*, Edizione del Cavallino, Venice 1944, in an edition of 125 copies.

12.

13.

MASSIMO CAMPIGLI

"Woman at Loom", 1951

(Donna al telaio)

signed and dated lower right *Campigli 51*

sanguine on paper 46 x 56.5 cm

Provenance: presently unknown

14.

MASSIMO CAMPIGLI

"Shop Windows", 1945

(Vetrine)

signed lower right CAMPIGLI

watercolour over lithograph

22.5 x 29 cm (irregular)

Provenance: purchased from St. George's Gallery, London 1949.

Estorick always called this work "Multiplication". It is part of a suite of ten lithographs made by Campigli for R. Carrieri's *Lamento di gabelliere,* Toninelli, Milan 1945 in an edition of 250 copies.

15.

MASSIMO CAMPIGLI

"Woman at Loom", 1951

(Donna al telaio)

signed lower left in pencil CAMPIGLI

and numbered lower right LV/CX

coloured lithograph 48.5 x 34.6 cm

Provenance: presently unknown.

13.

14.

15.

16.

16.

MASSIMO CAMPIGLI

Untitled, 1948

signed lower right in pencil *Campigli 48*

pen, black ink and pencil on paper 14 x 20 cm

Provenance: purchased from St. George's Gallery, London 1949.

17.

MASSIMO CAMPIGLI

"The Kiss", 1948

(Il bacio)

signed lower right in pencil *Campigli*

and inscribed lower left *prova*

20 x 14.8 cm

Provenance: purchased from the artist (?).

This print forms part of a suite of twelve lithographs from André Gide's *Theseus*, with an English translation by J. Russell and printed by Officina Bodoni, Verona, in 1949 in an edition of 200 copies. The first thirty copies had a second series of illustrations and a series of studies printed on Chinese paper. "The Kiss" was always known by Estorick as "Theseus I". A copy of the book appeared in the catalogue of the St. George's Gallery exhibition in 1949, although, as this is an artist's proof, it is likely Estorick purchased it directly from Campigli.

17.

18.

MASSIMO CAMPIGLI

"Fedra III - Phaedra", 1948

signed lower right *Campigli*

inscribed lower left *prova*

lithograph 18 x 15 cm

Provenance: purchased from the artist (?).

Previously called "Theseus II" by Estorick. This is another lithograph from Andre Gide's *Theseus* (see cat. 17).

18.

19.

Massimo Campigli

Study for "Lira Divina", 1944

signed and dated lower right *Campigli 44*

numbered lower left 2/2

lithograph 18.7 x 26.5 cm

Provenance: purchased from St. George's Gallery, London 1949.

Estorick always called this lithograph "Seven Women Playing", whereas it is a variation on *Lira Divina* in *Liriche di Saffo*, Edizione del Cavallino, Venice 1944. The Estorick version has one less figure behind the lyre player to the immediate left.

19.

20.

Carlo Carrà

"Leaving the Theatre", 1910-1911
(Uscita dal teatro)

signed lower left *C. D. Carrà*

oil on canvas 69 x 91 cm

Provenance: purchased from Sotheby & Co., London, 3.12.1958, Lot No. 126; previously Max Rothschild, London.

Carrà's "Leaving the Theatre" typifies Futurist representation in many respects. The skewed horizon line and strong diagonals are meant to disrupt the two dimensional picture plane. The blurred edges and intense colouring of Carrà's Divisionist-inspired application of paint heighten the sensation of flux, revealing a perception that is both dynamic and perpetually in motion. The mundane, urban theme is a mainstay of Futurist subject matter and features prominently in Carrà's Milanese paintings of the period. His inclusion of electric streetlights, here lining the background walkways, reflect the Futurist obsession with technological novelties. The painting was first exhibited at Galerie Bernheim-Jeune, Paris, in February 1912. It was purchased by Max Rothschild (one of the first admirers and collectors of Futurism outside Italy) from the Futurist's London exhibition at the Sackville Gallery.

20.

21.

22.

21.

CARLO CARRÀ

"Boxer", 1913

(Pugilatore)

signed and dated lower right *C. Carrà 913;*

on verso *Carlo Carrà Pugilatore*

charcoal, pencil and black ink on paper

44.4 x 28 cm

Provenance: purchased from the artist in 1956.

22.

CARLO CARRÀ

"Synthesis of a Café Concert", 1910 - 1912

(Sintesi di un caffè concerto)

signed and dated lower left *C. Carrà 910*

and inscribed lower right

charcoal on paper 76.5 x 66 cm

Provenance: purchased from the artist in 1956.

23.

GIORGIO DE CHIRICO

"The Revolt of the Sage", 1916

(La rivolta del saggio)

signed and dated lower right *G. de Chirico 1916*

oil on canvas 66.5 x 53 cm

Provenance: purchased from Roland Penrose in 1954; previously René Gaffé, Brussels.

Roland Penrose acquired "The Revolt of the Sage" either in June 1937 from the Zwemmer Gallery, or in another De Chirico exhibition held in October 1938 at the London Gallery, of which Zwemmer was a director (see cat. 24). The still lifes of this period (1916-1917) were apparently inspired by his walks through the city of Ferrara with his new friend, Filippo de Pisis, who at that time was a young writer, publishing *La città dalle 100 meraviglie* on Ferrara's many attractions in 1920. De Chirico's active military service ceased when he was diagnosed as suffering from neuropsychiatric disorders (a profound nervous depression). "The Revolt of the Sage" was painted at the time De Chirico was in the military hospital, his health rapidly declining in direct response to the escalation of the war. "The Revolt of

the Sage", along with two works painted at the same time, "The Regret" and "The Faithful Servitor", all have objects crowding the picture plane and closing in from all sides. In one sense this series of paintings is perhaps a case of art imitating life, as De Chirico felt increasingly oppressed by both his immediate surroundings and the ongoing global catastrophe.

23.

24.

GIORGIO DE CHIRICO

"Melanconia", 1912

signed and dated lower right *G. de Chirico 1912*

oil on canvas 78.5 x 63.5 cm

Provenance: purchased from Peter Watson in 1955; previously René Gaffé, Brussels.

René Gaffé was a Belgian collector and dealer based in Switzerland who sold thirty pictures from his collection (which also included outstanding Picassos) to Anton Zwemmer when he fell on hard times. He is believed to have met Zwemmer at the "International Surrealist Exhibition" in London (1936) where "Melanconia" was on display. In June 1937 Zwemmer put on a joint exhibition of works by Picasso and De Chirico. Peter Watson, a Director of the London Gallery and associate of Zwemmer's, acquired "Melanconia" (see N. V. Halliday, *More than a Bookshop: Zwemmer's and the art of the 20th Century*, London 1991).

In Greek mythology, Ariadne, daughter of Minos of Crete, and half sister to the Minotaur, was abandoned by Theseus on the island of Naxos after she helped him slay her half brother; she later married Dionysus. The iconographical motif of the statue of Ariadne was first used by De Chirico in this painting and would occur repeatedly in later paintings including "The Melancholy of a Beautiful Day" and "The Lassitude of the Infinite" (both 1913). Several Roman copies of the lost Greek statue would have been available for De Chirico to study either in the Vatican or Florence. It is certain that the Greek fertility goddess had a profound significance for De Chirico, perhaps recalling his Greek childhood. "Souvenir d'Italie" (1914) is closely related to "Melanconia", but shows the statue without the inscription and has a different painterly treatment of the shadow-play and architecture.

24.

25.

26.

27.

25.

GIORGIO DE CHIRICO

"The Autumn Arrival", n. d.

(L'arrivo d'autunno)

inscribed with the title lower centre

pen and black ink and pencil 23 x 30.6 cm

Provenance: date of purchase presently unknown; previously Paul Eluard, Paris.

This drawing is very close in composition to *Piazza d'Italia*, 1913, oil on canvas, 60 x 84 cm in the Barnes Collection, U.S.A. (See *Giorgio de Chirico. Catalogo Generale*, Vol. 3, Milan 1973, No. 168).

26.

EMILIO GRECO

"Nude", 1953

(Nudo)

signed lower right *Greco*; on verso *Emilio Greco Roma: Largo di Villa Massimo*

pen and brown ink on paper 41.8 x 31.2 cm

Provenance: presently unknown.

27.

RENATO GUTTUSO

"Death of a Hero", 1953

(Eroe proletario)

signed and dated lower right *Guttuso 53*;

on verso inscribed *Eroe proletario Guttuso 53*

and numbered *22*

oil on canvas 88 x 103 cm

Provenance: purchased from the Leicester Galleries, London, in 1955.

Throughout his career Guttuso favoured a strongly realistic style and saturated palette. In the late 1940s and early 1950s, partly motivated by his communist beliefs, Guttuso championed an educative, socially committed art. A further platform for such ideas was found in the artistic group "Fronte Nuovo delle Arti", of which Guttuso was joint founder. In his many writings Guttuso believed that abstract art failed to engage popular audiences and had become the preserve of specialists and aristocrats. A real-

28.

29.

istic style, in contrast, had the potential to arouse sympathy and prompt political change. "Death of a Hero" is a subject that is easily understood: the iconography of the red flag of Communism, the intimacy of the scene, the extreme foreshortening of the figure in his hospital bed (recalling Mantegna's "Dead Christ") all clearly indicate that this is a political martyr, or more precisely, an icon for political martyrdom.

A preparatory oil sketch for this work exists (private collection, Verona, see E. Crispolti, *Catalogo ragionato generale dei dipinti di Renato Guttuso*, Milan 1983, p. 259) in which the bed occupies a more central position and the red flag cascades down the edge of the canvas. Less of the length of the figure is visible and the right arm is straight and outstretched. The final painting exhibits more drastic foreshortening and a darker background, heightening the drama of the scene. The painting has been referred to by several different titles since it was painted; Estorick always referred to it as "Death of a Hero". In exhibitions prior to Estorick's purchase of the work it was known as "Dead" or "Killed Worker" (London, Leicester Galleries, 1955; Rome, Galleria del Pincio 1953). In recent years the painting has been called "A Hero of Our Time" (Venice, Palazzo Grassi 1982, Stockholm, Moderna Museet 1978).

28.

RENATO GUTTUSO

"Landscape with Lovers", n. d.

(Paesaggio con amanti)

pastel on paper 48.5 x 68 cm

Provenance: presently unknown.

29.

GIACOMO MANZÙ

"Bust of a Woman", 1952

(Busto femminile)

foundry stamp on reverse

bronze with brown / green patina

height 66 cm

Provenance: presently unknown.

This bust depicts Signora Lampugnani, who had originally commissioned Manzù to sculpt her child; Manzù was so impressed with the woman herself that he asked her permission to do a full length portrait. This was only one of two occasions Manzù kept the plaster model after a first cast was made. The original 1947 bronze won the Grand Prize for Manzù at the Venice Biennale in 1948. Two subsequent bronzes, the 1952 version in the Estorick Collection and a 1955 version, were made after the original plaster was remodelled. In the Estorick version the torso has been built up probably by adding clay to the original plaster. In the 1955 version, the 1948 plaster head was attached to a different torso.

30.

31.

30.

MARINO MARINI

"Small Bather", 1945

(Piccola bagnante)

stamped *MM* on left buttock

bronze height 23 x 29 cm

Provenance: presently unknown.

Eric Estorick purchased many Marini bronzes from commercial galleries in Switzerland and London during the mid-1950s. All works itemised were for clients and not for his personal collection. Since Estorick's recollection is that these small bronzes (cats. 30-32) were purchased much earlier, it is possible they came directly from the artist. Marini's letter to Salome Estorick dated 20 December 1952, refers to a group of sculptures he had sent from Italy.

In H. Read, P. Waldberg and G. di San Lazzaro, *L'Œuvre Complet de Marino Marini*, Paris/Milan 1970, two other bronzes of the "Small Bather" are listed in the Milanese Collections of Riccardo Jucker and J. Nehmad.

31.

MARINO MARINI

"Quadriga", 1942

stamped with initials lower right *MM*

bronze 51 x 52 cm

Provenance: purchased in 1949 (?); source presently unknown.

This is one of the few examples of a bas-relief panel made by Marini. At least four other casts are in the edition. (See H. Read, P. Waldberg and G. di San Lazzaro, *L'Œuvre Complet de Marino Marini*, Paris/Milan 1970, cat. 125).

32.

MARINO MARINI

"Pomona", 1943

bronze; traces of surface colouring

height 43 cm

Provenance: purchased in 1950 (?); source presently unknown.

In Roman mythology Pomona was an agricultural divinity who presided over cultivated gardens and orchards. For Marini she was both a potent symbol of Italy's ancient cultural heritage and a figure of fecundity and timeless beauty. Marini used the subject of Pomona for a series of works begun in 1939; it was one to which he returned in subsequent years. By abrading the surface of the figures, and leaving some limbless, Marini intended to evoke the primitive power he had discovered in Etruscan art. (The Estorick version is not listed in H. Read, P. Waldberg and G. di San Lazzaro, *L'Oeuvre Complet de Marino Marini*, Paris/Milan 1970, cat.135).

33.

MARINO MARINI

"Horse and Rider", 1949
(Cavallo e cavaliere)

also known as "Horse and Falling Figure"
(Cavallo e figura che cade)

signed and dated lower right *Marini 49*

tempera on card 34 x 50 cm

Provenance: presently unknown.

32.

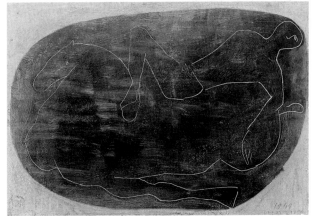

33.

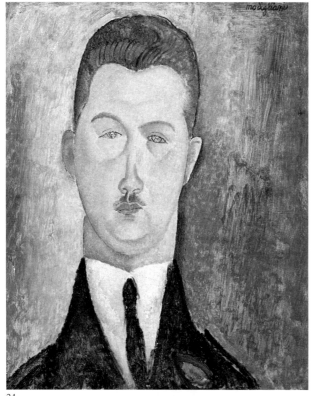

34.

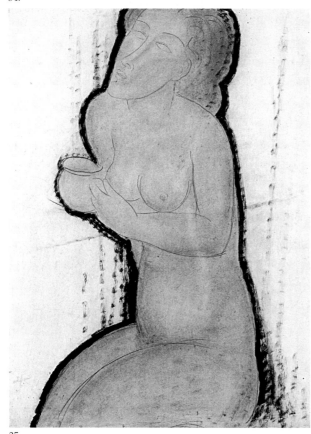

35.

34.

AMEDEO MODIGLIANI

"Doctor François Brabander", 1918

signed upper right *Modigliani*

oil on canvas 46 x 38 cm

Provenance: purchased from Otto Gerson Fine Arts, New York in 1956; previously Henry Pearlman, New York; Lionello Venturi, Rome; Dr François Brabander, Paris (until 1933).

This portrait dates from the last years of Modigliani's life, when Leopold Zborowski was acting as his dealer and benefactor. Fearing for Modigliani's health and that of his pregnant mistress, Jeanne Hébuterne, the Zborowskis travelled with the ailing couple to the South of France in the spring of 1918 for an extended stay until the following year. It is therefore likely that this portrait was painted during this time. Zborowski and his wife, Anna, sat for Modigliani on a number of occasions and often supplied friends and relatives for the artist to paint both in Paris and the south of France. Although the identity of Doctor Brabander was questioned as recently as 1970 (J. Lanthemann, *Modigliani 1884-1920: Catalogue Raisonné, sa vie, son œuvre complet, son art*, Barcelona 1970, cat. 318), Anna Zborowski confirmed the sitter to be her brother-in-law in 1949. On the back of a photographic reproduction of the painting, supplied to her by Lionello Venturi, Anna Zborowski wrote:

> I the undersigned, Madame Leopold Zborowski, certify that this oil portrait of my brother-in-law, Doctor François Brabander, is an authentic work by Modigliani. Painted in the year 1918, the portrait remained in the possession of my brother-in-law until 1933. At this time it was purchased by Mr Lionello Venturi. It is the only oil portrait of my brother-in-law by Modigliani. Doctor Brabander - deported for his political activities - died in Bergen-Belsen in 1945, after three years in captivity.

While enlightening, this actively calls into question the status of a second portrait featuring a seated man who very closely resembles Doctor Brabander (*Ibid.*, cat. 319).

35.

AMEDEO MODIGLIANI

"Nude with Cup", 1918

(Nudo con tazza)

signed lower left *Modigliani*

watercolour, black wash and pencil on paper

64 x 49 cm

Provenance: purchased in 1956; previously Ernest Heller, New York; Pierre Matisse; Paul Guillaume, Paris.

92

36.

GIORGIO MORANDI

"Still Life", 1944

(Natura morta)

signed and dated lower right *Morandi 44*

pencil on paper 22.4 x 31.6 cm

Provenance: date of acquisition unknown; previously Galleria dell'Annunciata, Milan (see E. Tavoni, *Disegni. Catalogo generale*, Milan 1994, p. 81).

36.

37.

GIORGIO MORANDI

"Still Life", 1953

(Natura morta)

signed and dated lower centre *Morandi 53*

pencil on paper 16.4 x 23.5 cm

Provenance: purchased from Philip Granville, London, in 1956.

37.

38.

GIORGIO MORANDI

"Still Life", 1959 (?)

(Natura morta)

signed lower centre *Morandi*; on verso stamped

Galleria del Milione Via Bigli 2 Milano

and numbered in pencil *876*

pencil on paper 18.7 x 27.1 cm

Provenance: Galleria del Milione, Milan (?).

38.

39.

40.

41.

39.

GIORGIO MORANDI

"Landscape", 1942

(Paesaggio)

signed lower left *Morandi 1942*; on verso *Galleria del Milione, Via Brera 21 Milano No. 2457/1*

pencil on paper 24 x 32.4 cm

Provenance: Galleria del Milione, Milan (?); previously in the collection of P. Rollino, Rome.

The drawing is thought to be related to an oil painting of the same year (see L. Vitali, *Morandi. Catalogo generale*, Vol. 1, Milan 1977 (2nd edition 1983), No. 396, and E. Tavoni, *Disegni. Catalogo generale*, Milan 1994, p. 73).

40.

GIORGIO MORANDI

"Bridge over the Savena in Bologna", 1912

(Il Ponte sul Savena a Bologna)

signed lower right *Morandi 1912*; inscribed lower left *prova di stampa* and dedicated bottom right *Al Signor Mr Eric Estorick Giorgio Morandi*

etching on wove paper 16.6 x 22.2 cm

Provenance: gift of the artist.

This is the first of all Morandi's etchings (see M. Cordaro, *Morandi. Incisioni. Catalogo generale*, Milan 1991, p. 3).

41.

GIORGIO MORANDI

"Still Life with Vases and Bottles etc. on a Table", 1929

(Natura morta di vasi, bottiglie ecc. su un tavolo)

signed lower right *Morandi*, numbered lower left *17/62*

etching 14.5 x 19.5 cm

Provenance: presently unknown (see M. Cordaro, *Morandi. Incisioni. Catalogo generale*, Milan 1991, p. 74).

42.

GIORGIO MORANDI

"Hill in the evening", 1928

(Il Poggio di sera)

signed and dated lower right *Morandi 1928*;

numbered lower left *19/50*

etching 14 x 24 cm

Provenance: presently unknown (see M. Cordaro, *Morandi. Incisioni. Catalogo Generale*, Milan 1991, p. 49).

42.

43.

GIORGIO MORANDI

"Still Life with Condiment Dish, Long Bottle and Fluted Bottle", 1928

(Natura morta con compostiera, bottiglia lunga e bottiglia scannellata)

signed and dated lower right *Morandi 1928*;

numbered lower left *10/50*

etching 23 x 18 cm

Provenance: purchased from Libreria Prandi, Reggio Emilia in 1960 (see M. Cordaro, *Morandi. Incisioni. Catalogo generale*, Milan 1991, p. 57).

43.

44.

GIORGIO MORANDI

"Mountains of Grizzana", 1929

(Monti di Grizzana)

signed lower right *Morandi*

and numbered lower left *34/50*

etching 13.5 x 16.5 cm

Provenance: purchased from Libreria Prandi, Reggio Emilia in 1960 (see M. Cordaro, *Morandi. Incisioni. Catalogo generale*, Milan 1991, p.66).

44.

45.

47.

46.

46.

GIORGIO MORANDI

"Landscape (The Chimneys of the Arsenal
on the Outskirts of Bologna)", 1921

(Paesaggio - I camini dell'arsenale
nei dintorni di Bologna)

signed lower left *Morandi*

and dated lower right *1921*

etching 8.1 x 9.2 cm

Provenance: presently unknown (see M. Cordaro, *Morandi. Incisioni. Catalogo generale*, Milan 1991, No. 7, p. 12).

45.

GIORGIO MORANDI

"Landscape - Chiesanuova", 1924

(Paesaggio - Chiesanuova)

signed lower left *Morandi*

and dated lower right *1924*

etching 16 x 15.5 cm

Provenance: purchased from Libreria Prandi, Reggio Emilia in 1960 (see M. Cordaro, *Morandi. Incisioni. Catalogo generale*, Milan 1991, p. 25).

47.

ZORAN MUSIC

"Black Mountain", 1952

(Montagna nera)

signed and dated lower right *Music 1952*

and signed and dated on verso

oil on canvas 60 x 72.5 cm

Provenance: purchased in 1957.

48.

49.

50.

48.

ZORAN MUSIC

"Horses and Landscape", 1951

(Motivo Dalmata)

signed and dated lower centre *Music 1951*;

signed, inscribed with title and dated on verso

oil on canvas 81 x 100 cm

Provenance: purchased in 1956.

49.

ZORAN MUSIC

"Corsican Motif", 1966

(Motivo Corso)

signed and dated *Music 66* and dedicated

lower right; signed and inscribed

with title and dated *66* on verso

oil on canvas 60.5 x 81 cm

Provenance: gift of the artist.

50.

OTTONE ROSAI

"Man Waiting", 1919

(Uomo che aspetta)

signed lower right *O R*

oil on canvas 21.5 x 21 cm

Provenance: purchased from Francesco Monotti, Rome, in 1953.

51.

51.

MEDARDO ROSSO

"Impressions of the Boulevard:
Woman with a Veil", 1893

(Impressioni di boulevard: donna con veletta)

wax 60 x 59 x 25 cm

Provenance: purchased in 1957; source presently unknown.

In J. de Senna, *Medardo Rosso o la creazione dello spazio moderno*, Milan 1985 and M. Fagioli, *Medardo Rosso*, Florence 1993 (p. 98), both authors list seven wax versions of "Woman with a Veil". No reference is made to the Estorick version which was first shown by the collector in "Italienische Kunst im XX Jahrhundert", Akademie der Kunst, Berlin in 1957, an exhibition organised in collaboration with the Galleria del Milione, Milan. The title for this sculpture was first used by Ardengo Soffici in *Il caso Medardo Rosso* published in 1909 to distinguish between *Impressions of the Boulevard: Woman with a Veil* and *Impression de Boulevard: Paris La Nuit.*

52.

52.

LUIGI RUSSOLO

"Music", 1911

(Musica)

signed lower right *L Russolo*

oil on canvas 220 x 140 cm

Provenance: purchased from Maria Zanovello Russolo in 1956.

When the painting was sold a description accompanied it:

With this painting the author has wanted to make a sort of pictorial tradition of the melodic, rhythmic, harmonic, polyphonic and colouristic impressions which make up the whole of musical emotions. On a light-blue sky, progressively shaded in circles to render the spatial widening out of the sound waves, a spectral musician frenzied by the ecstasy of inspiration draws a whirl of sounds, rhythms and chords from a huge keyboard; the unfurling of the melody in time is pictorially translated into that deep blue wave which, unfurling snake-like in space, dominates and wraps around the whole painting. Like unexpected meteors which mark their wake in light-blue space, many calm, gay or grotesque masks gather together, intertwine themselves, place themselves on top of each other forming harmonious chords or complementaries of bright colours, thus translating those indefinite sentiments belonging to music into definite human expressions. These differently grouped and variously coloured masks form among themselves harmonies of pictorial colour, reflections and echoes of musical chords, timbres and colours.

"Music" and his earlier painting "Perfume" (1909-1910) perhaps reflect Russolo's interest in early twentieth century explorations into synaethesia whereby sensations in one sensory mode recall impressions in others. The composer, Scriabin, experimented with colour-sound compositions between 1909 and 1910 and Kandinsky made intuitive equations between music, sound and colour. It is thought that the pianist in "Music" represents either Beethoven or Siva Nataraja, the Hindu creator and lord of the cosmic dance, as Russolo was very interested in oriental philosophy. The painting was first shown at the "Esposizione Libera", but Russolo is thought to have repainted his composition after the exhibition. It was first exhibited in its present form at the Futurists' Rotterdam exhibition of May 1913 (see M. Martin, *Futurist Art and Theory, 1909-1915*, Oxford 1968, pp. 89-90).

53.

53.

GINO SEVERINI

"Portrait of Mlle Susanne Meryen

of Varietà", 1913

(Ritratto di Mlle Susanne Meryen del varietà)

signed and dated lower right *G. Severini 1913*

and dedicated *al caro amico Marinetti ricordando*

le belle manifestazioni di altri tempi, con affetto

sempre grande, Gino Severini [*To my dear friend*

Marinetti in memory of those wonderful

manifestations of times gone by, with much love

as always, Gino Severini]

watercolour on paper 73 x 54 cm

Provenance: purchased from Benedetta Marinetti in 1950; previously Kahnweiler Collection, Paris.

This is one of the drawings shown at Severini's exhibition held at the Marlborough Gallery, London in 1913 (cat. 28, p. 11). The dedication to Marinetti was added later, when Severini gave the watercolour to F. T. Marinetti as a present (see D. Fonti, *Gino Severini. Catalogo ragionato*, Milan 1988, cat. 155).

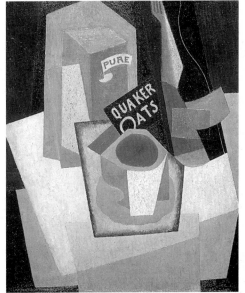

54.

54.

GINO SEVERINI

"Quaker Oats - Cubist Still Life", 1917

(Quaker Oats - natura morta cubista)

signed and dedicated lower right *au Docteur*

Raymond Geiger avec estime et amitié. G. Severini

oil on canvas 62 x 51 cm

Provenance: purchased in 1952(?), source unknown; previously R. Geiger.

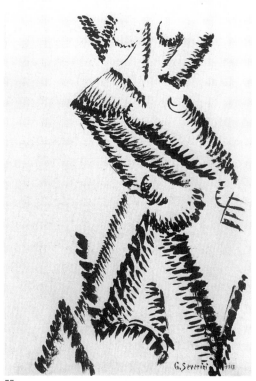

55.

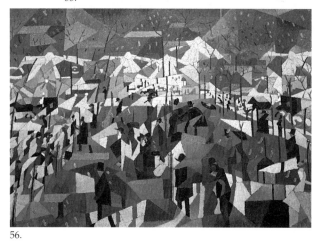

56.

55.

GINO SEVERINI

"Dancer (Tango Argentino)", 1913

(Danzatrice - Tango argentino)

signed and dated lower right *G Severini 1913*

black ink on paper 26.5 x 17.8 cm

Provenance: purchased from Sotheby & Co., London, 7 July 1960, Lot 116; previously John Rewald; Heinz Berggruen; J. W. Alsdorf, Chicago.

56.

GINO SEVERINI

"The Boulevard", 1910-1911

(Le boulevard)

oil on canvas 63.5 x 91.5 cm

Provenance: purchased from F. H. Mayor, London, in 1951; previously Max Rothschild, London.

"The Boulevard" was one of the highlights of the Futurist exhibition at the Sackville Gallery, London, in 1912 and was described in the catalogue as: "Light and shadow cut up the bustle of the boulevard into geometric shapes". M. Martin (*Futurist Art and Theory, 1909 - 1915*, Oxford 1968) considered "The Boulevard" to be a Futurist version of an earlier painting "Springtime in Montmartre" of 1909. In his autobiography Severini describes a visit by Georges Braque in 1910, "Braque took an interest in what I was doing. I had just started the 'Pan Pan à Monico', but was able to show him 'La Modiste', various still lifes, and 'The Boulevard', in which I had broken down forms just as I had colours" (*The Life of a Painter*, Princeton 1995, p. 62).

57.

GINO SEVERINI

"Dancer (Ballerina + Sea)", 1913

(Danzatrice [Ballerina + mare])

signed and dated lower right *G. Severini 1913*

oil, gouache, black wash and pastel on board

75.5 x 50.5 cm

Provenance: date of purchase unknown; previously Severini, Rome; Ghiringhelli, Milan.

Gino Severini applied the Futurist ideas of dynamism and simultaneity to subjects from his immediate surroundings in a style informed by the latest avant-garde developments in Paris. Between 1910 and 1914 cabaret life, and more particularly dancers, dominated Severini's imagery. "Ballerina + mare", in a style clearly conversant with Cubism, shows the dancer's movements in terms of sweeps and curved tracings of motion with intermittent shading of volumetric forms.

58.

Mario Sironi

"Man with Top Hat"

(drawing for a political cartoon), n. d.

(L'uomo con il cappello a cilindro)

signed lower right *Sironi*

charcoal on paper 18.5 x 20 cm

Provenance: purchased from the artist in 1948.

59.

Mario Sironi

"The Metaphysical Robot Arant

(Cylindrical Figure with Animal)", 1915

(Il robot metafisico Arant - Figura cilindrica con animale)

pen and gouache on paper

28 x 21.5 cm (irregular)

Provenance: purchased from the artist in 1948.

58.

59.

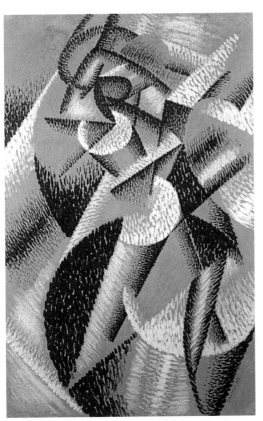

57.

60.

61.

60.

Mario Sironi

"Horse and Carriage in a Street", 1917-1918

(Cavallo e carro su una strada)

pencil on paper 27 x 21 cm

Provenance: purchased from the artist in 1948.

62.

61.

Mario Sironi

Untitled (known as "Man Opening Door"),
1932

(Uomo che apre la porta)

signed lower left *Sironi*

black wash, charcoal and white gouache

on paper 25.5 x 22 cm

Provenance: purchased from the artist in 1948.

Illustration for the novel *La pelliccia di visone* by Ezio Ca-
muncoli published in "La Rivista Illustrata del Popolo
d'Italia", Anno X, No. 6, June 1932, p. 36. "La Rivista
Illustrata del Popolo d'Italia" was published from August
1923 until July 1943 as a monthly magazine. Sironi contrib-
uted throughout its existence.

62.

Mario Sironi

"Nude (Standing Figure)", 1914

(Nudo - Figura in piedi)

pen and brown ink on mauve paper

20 x 15 cm

Provenance: purchased from the artist in 1948.

63.

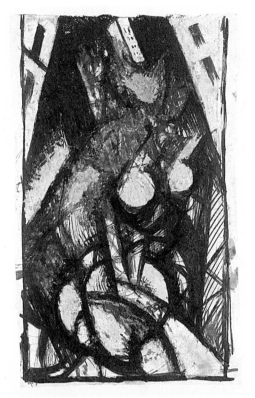

63.

Mario Sironi

"Group of Figures", c. 1936

(Gruppo di figure)

signed lower right *Sironi*

pencil on paper 15.5 x 23 cm

Provenance: purchased from the artist in 1948.

64.

64.

Mario Sironi

"Futurist City", 1914

(Città futurista)

black ink and gouache on paper 16.2 x 10.2 cm

Provenance: purchased from the artist in 1948.

65.

Mario Sironi

"Horse with Geometric Rider", c. 1914

(Cavallo e cavaliere geometrico)

gouache and collage on paper 25 x 20 cm

Provenance: purchased from the artist in 1948.

65.

66.

66.

Mario Sironi

"Five Standing Figures", n. d.

(Cinque figure in piedi)

pencil and gouache on paper 21.6 x 27.5 cm

Provenance: purchased from the artist in 1948.

67.

67.

Mario Sironi

Untitled (Woman, Horse and Cat), 1915

(Donna, cavallo e gatto)

brown wash on paper laid on card 15.5 x 13 cm

Provenance: purchased from the artist in 1948.

68.

Mario Sironi

"Man and Python"

(drawing for a political cartoon), 1924

(Uomo e pitone)

signed lower right *Sironi*

black wash on paper 17.5 x 23.5 cm

Provenance: purchased from the artist in 1948.

It is likely this is a preparatory drawing for *Vecchio Parla-mentarismo...* in "Il Popolo d'Italia", No. 43, 19 February 1924, p. 3. (See *Sironi illustratore. Catalogo ragionato*, Rome 1988, No. 609, p. 83.)

68.

69.

MARIO SIRONI

"Urban Landscape", c. 1924

(Paesaggio urbano)

oil on paper laid on panel 28 x 40 cm

Provenance: purchased from the artist in 1948.

70.

MARIO SIRONI

Drawing for a political cartoon, n. d.

signed lower right *Sironi*

and inscribed lower centre

charcoal on paper 26.2 x 23 cm

Provenance: purchased from the artist in 1948.

71.

MARIO SIRONI

"Dancing on Stage", n. d.

(Ballo sul palcoscenico)

signed lower right *Sironi*

oil on board 29.5 x 44 cm

Provenance: purchased from the artist in 1948.

69.

70.

71.

72.

72.

MARIO SIRONI

"Figure with Corpse", 1942

(Figura con cadavere)

signed lower right *Sironi*

gouache 25.5 x 37.5 cm

Provenance: purchased from the artist in 1948.

73.

73.

MARIO SIRONI

"Two Figures", 1932

(Due figure)

pencil, grey and black wash heightened

with white 31.8 x 47 cm

Provenance: purchased from the artist in 1948.

74.

74.

MARIO SIRONI

"Urban Landscape, Aeroplane

and Seated Woman", 1916

(Paesaggio urbano, aeroplano e donna seduta)

pencil on paper laid on card 27 x 20.5 cm

Provenance: purchased from the artist in 1948.

75.

MARIO SIRONI

"Three Huts on a Hillside", n. d.

(Tre baracche sulla collina)

signed lower right *Sironi*

tempera on paper laid on canvas 20 x 30.5 cm

Provenance: purchased from the artist in 1948.

76.

MARIO SIRONI

"Three Mountains", n. d.

(Tre montagne)

signed lower right *Sironi*

tempera on paper laid on canvas 16 x 22.5 cm

Provenance: purchased from the artist in 1948.

77.

MARIO SIRONI

"Death in the Landscape", n. d.

(Morte nel paesaggio)

signed lower right *Sironi*

tempera on paper laid on canvas 16 x 22.5 cm

Provenance: purchased from the artist in 1948.

75.

76.

77.

78.

ARDENGO SOFFICI

"Decomposition of the Planes of a Lamp", 1912-1913

(Scomposizione dei piani di un lume)

oil on panel 45 x 34 cm

Provenance: purchased from Benedetta Marinetti in 1950. (This work was greatly admired by Carlo Carrà who prompted F. T. Marinetti to acquire it).

Soffici met Picasso as early as 1901 and through the course of their friendship witnessed first hand the development of Cubism from its earliest stages. Soffici visited Picasso's studio on a number of occasions while residing in Paris from 1900 until 1906 and later as a frequent visitor to the capital, until the First World War. He was unique among Picasso's friends in his appreciation of "Les Demoiselles d'Avignon", a landmark in Cubism's early formation. Writing repeatedly on the subject, Soffici introduced Cubism to Italians through the pages of the Florentine journals "La Voce" and "Lacerba". *Picasso and Braque* (1911) was followed by the more lengthy essay *Cubismo e oltre* (1913). The latter formed part of the book *Cubismo e futurismo* (1914) in which "Scomposizione dei piani di un lume" was first reproduced. "Scomposizione dei piani di un lume" was in progress a few weeks before it was exhibited at the Teatro Costanzi exhibition (February 1913) where Soffici was invited to make his Futurist debut. Later in 1913 it was shown in Rotterdam and Berlin, where, perhaps significantly, it was exhibited in a room shared with Robert Delaunay, not with the original Futurist group. Although Soffici's adoption of a Cubist-influenced style was extremely brief, several other paintings dating from 1912-1913 illustrate a similarly careful study of Cubism's pictorial method and muted palette (see A. Noble's essay, fig. 5). Subsequent dating of "Scomposizione dei piani di un lume" to the year 1912 contradicts Soffici's own attribution of 1913 in *Cubismo e futurismo*. It is probable that the execution of the painting spanned the end of 1912 and the beginning of 1913.

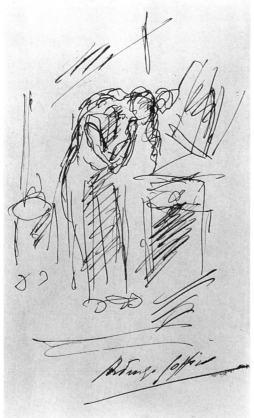

79.

ARDENGO SOFFICI

"Woman Combing Her Hair", 1913-1914

(Donna che si pettina)

signed lower right *Ardengo Soffici*

pen and black ink 22 x 14 cm

Provenance: purchased from the artist in the mid-1950s.

Biographies of the Artists

Biographies of the Artists

GIACOMO BALLA (1871-1958)

Balla was born on 18 July 1871 in Turin and studied music as a child. After the death of his father in 1880, he worked in a printing shop and took drawing classes. He studied at the Accademia Albertina for a short time, but was mostly self-taught as an artist. Guiseppe Pellizza da Volpedo and Giovanni Segantini, advocates of Divisionism, were early influences. Divisionism, developed in northern Italy, sought to revive Italian painting through an innovative use of colour and socially committed subject matter. It was a quasi-scientific method of painting, reflecting late nineteenth century interest in colour theory and allowed artists to explore a greater range of emotion with expressive colour combinations and unusual light effects.

Balla moved to Rome in 1895 and adopted a socialist political stance. Portraits and landscapes dominated his art of the period. Balla was drawn to Paris by the Exposition Universelle in 1900, where he remained for seven months working as an illustrator. He returned to Rome in 1901 and began teaching, promoting Divisionist techniques amongst his students who included Boccioni and Severini. At this time the theme of work pervaded his canvases, along with other humanitarian issues.

Encouraged by Boccioni, Balla joined the Futurists in 1910, but did not exhibit with them until 1913. In 1912 he initiated a series of movement studies and went to Düsseldorf to decorate the interior of the Löwenstein home. There he began a series of non-objective, geometric colour studies, *Iridescent Compenetrations*. Balla's interest in movement was later directed towards abstract analytical studies of speeding cars and swifts in flight (1913-1914). From 1913 he also experimented with sculpture, making abstract constructions from modern materials such as cardboard, wire and fabric. Many of Balla's unrealised designs were posthumously fabricated in the late 1960s. From 1914 Balla's activity with the Futurists increased as he extended Futurist principles to a variety of media. In his manifesto *Anti-Neutral Clothes*, fashion design became an expression of interventionist fervour; he also contributed to "Interventionist Demonstrations", multimedia events intended to engender support for Italy's participation in the First World War. He experimented with *parole-in-libertà* (words-in-freedom) and acted in and designed sets for Francesco Cangiullo's theatrical productions. With Fortunato Depero he wrote and illustrated *Futurist Reconstruction of the Universe* (1915), a manifesto calling for the integration of Futurist principles into all aspects of modern life. Balla signed the *Manifesto of Futurist Cinema* (1916) having already appeared in the first Futurist film, *Vita futurista,* earlier the same year.

Balla spent the war in Rome; in the aftermath he found himself amongst a new group of artists brought together by Marinetti under the Futurist banner. Balla was by this time approaching the periphery of the movement and by 1920 his output was virtually restricted to the decorative arts, mostly furniture. He continued to exhibit with the new generation of Futurist artists at the Palazzo Cova, Milan (1919), the Rome Biennale and the Exposition des Arts Décoratifs in Paris with Fortunato Depero and Enrico Prampolini (1925). He developed a Futurist approach to interior design which he applied in the decoration of Casa d'Arte Bragaglia (1922) and Marinetti's house (1925).

Although he signed the *Manifesto of Aeropainting* (1929) and exhibited at the "First Exhibition of Futurist Aeropainting" (1931), Balla distanced himself from both Futurism and modernist trends. In a

radical stylistic about-face Balla turned to Realism in the late 1930s, considering abstraction only as a means of superficial decoration. His style remained strongly figurative until his death on 1 March 1958. [H. C.]

UMBERTO BOCCIONI (1882-1916)

Boccioni was born on 19 October 1882 in Reggio Calabria, the son of an itinerant government employee; his family moved to Forlì, Genoa, Padua and Catania before settling in Rome in 1899. There he met Mario Sironi and attended the Scuola Libera del Nudo, where, together with Gino Severini, he was instructed in the Divisionist style in the studio of Giacomo Balla. Divisionism and Symbolism remained Boccioni's primary influences until the end of the decade. Boccioni exhibited regularly from an early age, participating in the "Società degli Amatori e Cultori" exhibitions from 1903 to 1905 and the "Mostra dei Rifiutati" (1905); he visited Paris and the major cities of Western Russia in 1906 with recently-won prize money.

Boccioni returned to Italy in 1907, first going to Venice (where he met Modigliani briefly), before settling in Milan. He worked with unprecedented intensity during this period, attempting to devise a pioneering modern art devoid of stale convention. Impressed by the revolutionary spirit of *The Foundation* and *First Manifesto of Futurism*, Boccioni, Carrà and Russolo had approached its author, the poet F. T. Marinetti, by early 1910 and painting became integrated into what had hitherto been a literary movement. From the outset Marinetti acted as Futurism's *direttóre* and Boccioni as its most aggressive painter-zealot. In 1910 the *Manifesto of Futurist Painters* was released; it called for a new art that shed the conventions of tradition and good taste and expressed, "the whirling life of steel... and speed". A second manifesto quickly followed, and like its predecessor, it is considered to owe much of its content to Boccioni.

Futurist Painting, Technical Manifesto was launched in April 1910 and clarified the artists' programme. The principles underpinning Futurist art were put forward: dynamism referred to the sensation of speed and flux of reality and simultaneity to our intuitive ability to synthesise the minute stages of movement into a continuous sweep of motion. For Boccioni these ideas ultimately led to his attempts to meld subject and surroundings through increasing abstraction and harsh, hyper-colour combinations applied in the Divisionist fashion.

Around 1912 the artist became fascinated with sculpture after seeing the works of Medardo Rosso in Paris. He hastily wrote the *Manifesto of Futurist Sculpture* (11 April 1912). For the next two years he attempted to unite sculptural subjects with the space and objects which surrounded them; in one such attempt he implanted a section of window frame into a portrait head ("Fusion of Head and Window Frame", destroyed 1916). In 1914 Boccioni published the first lengthy book on the subject of Futurism, *Pittura scultura futuriste*.

Boccioni volunteered for the front in the First World War. He served with Marinetti, Russolo and Sironi in the Lombard Cyclists Brigade. The army released him from duty briefly in 1916 and Boccioni used his time to paint in a way that showed a renewed interest in Cézanne. He was recalled to duty and, after falling from his horse during a training exercise, died a few days later on 17 August. [H. C.]

MASSIMO CAMPIGLI (1895-1971)

Originally named Max Hilenfeld, Massimo Campigli was born on 4 July 1895 in Berlin. Raised by his maternal grandmother in Settignano, near Florence, Campigli believed his natural mother to be his sister, until the truth emerged after his family's move to Milan in 1909. He began a career in journalism on the Milanese newspaper "Corriere della Sera", working as a secretary. He met Boccioni and Carrà at this time and published *Paper + Street: Words in Freedom* in "Lacerba" using the name Massimo Campigli for the first time.

Campigli enlisted in 1915 and was captured and imprisoned in Hungary (1916). He escaped and made his way to Moscow, where he presented himself to the Missione Militare Italiana. With the onslaught of the October Revolution, Campigli fled Russia on an English ship, arriving in London in October 1918. From there he returned to Milan and the "Corriere della Sera", but was soon transferred

to Paris as a correspondent. It was at this time that Campigli began to paint, influenced by Léger and Picasso and the avant-garde interest in purist geometries and volumetric forms. Campigli exhibited for the first time in 1921 at the Salon d'Automne. After his first one-man exhibition at Casa d'Arte Bragaglia in Rome (1923), Campigli began to incorporate ancient Egyptian compositional devices into his work, setting figurative groups in static, timeless poses. Increasingly, female subjects dominated his work. From 1926 Campigli exhibited with the "Novecento" group and developed links with the "Italiani di Parigi": De Chirico, Filippo de Pisis, Renato Paresce, Gino Severini, Alberto Savinio and Mario Tozzi. The following year he gave up journalism and concentrated on painting.

In 1928 Campigli was deeply affected by a visit to the Museo di Villa Giulia in Rome. The Etruscan art he saw there made him reappraise his approach; thereafter his paintings placed a new emphasis on pale colours, dry 'fresco-like' paint and archaic motifs. Campigli's work was well-received during this period; exhibitions at the Jeanne Bucher Gallery, Paris (1929) and the Galleria del Milione, Milan (1931), led to a series of international exhibitions, including shows in New York at the Julien Levy Gallery. From 1933 Campigli worked in Milan. He signed the *Manifesto of Mural Painting* and engaged in fresco projects throughout Italy. With Carrà, Severini and Sironi, he took part in the decoration of the Palazzo di Giustizia in Milan (1939).

After the war Campigli moved between Rome, Paris and St Tropez, enjoying great success; in 1948 he had his own room at the Venice Biennale. Throughout the 1940s and 1950s, Campigli's images were dominated by female heads and torsos in compartment-like structures. In later years his work diversified, incorporating complex architecural elements and heavily abstracted figures. He died in Saint Tropez in 1971. [H. C.]

CARLO CARRÀ (1881-1966)

Carrà was born on 11 February 1881 in Quargneto, Piedmont, the son of an artisan. In his youth he worked as a decorator and muralist, moving to Milan in 1895. In 1899 and 1900 he decorated pavilions for the Exposition Universelle and saw Impressionist and post-Impressionist paintings. From 1904 to 1905 Carrà attended evening classes before enrolling at the Accademia di Belle Arti in Milan. In 1906 he continued his studies at the Brera Academy where he met Boccioni. Carrà experimented with Divisionism, but like Boccioni was dissatisfied with current trends in painting. Together with Boccioni and Russolo, Carrà approached F. T. Marinetti, the author of the first Futurist manifesto, and participated in the drafting of the subsequent *Manifesto of Futurist Painters* and *Futurist Painting, Technical Manifesto*. He showed at the "Mostra d'arte libera" in Milan (1911) and in the travelling Futurist exhibitions of the following year. Carrà took part in Futurist *serate* and issued his manifesto of *The Painting of Sounds, Noises and Smells* in 1913.

He travelled to Paris in 1911 and 1912 with the Futurists and again in 1914 with Ardengo Soffici.

Carrà contributed regularly to the Florentine journals "La Voce" and "Lacerba" and developed a lifelong friendship with Ardengo Soffici who coedited the latter with Giovanni Papini. Despite Futurism's internal conflicts of 1914 and 1915 and his own experiments with Cubism and primitivism, Carrà backed Futurism's interventionist campaign. *Guerrapittura*, his book of incendiary essays and *parole in libertà* (1915), rallied support for Italy's participation in the First World War.

During the war, Carrà turned to Italy's artistic past for inspiration, particularly Giotto and Paolo Uccello. *Parlata su Giotto*, an essay hailing Giotto's plastic formal values, was published in "La Voce" in March 1916, followed by an impassioned study *Paolo Uccello costruttore* a few months later. Carrà met De Chirico in Ferrara in 1917 and the two formed the short-lived "Scuola metafisica". Carrà painted about thirteen interiors with disparate arrangements of objects and substantiated his metaphysical ideas in the Roman journal "Valori Plastici", to which he contributed throughout the 1920s. After his rela-

tionship with De Chirico dissolved in acrimony, Carrà worked briefly in a naive figurative style, before embarking on a series of naturalistic seascapes in the 1920s.

Carrà began writing for the influential Milanese newspaper "L'Ambrosiano" in 1921 and during 1922 was shown for the first time at the Venice Biennale and exhibited with the "Novecento" group. He showed again with "Novecento Italiano" in 1926 and 1929. In the late 1920s Carrà painted landscapes based on the surroundings of his summer home at Forte dei Marmi.

In 1930 Carrà began working on large-scale mural projects and signed Sironi's *Manifesto of Mural Painting*. In 1937 and 1938 he made frescoes for the Palazzo di Giustizia in Milan. In 1941 Carrà was appointed Professor of Painting at the Brera Academy, where a retrospective of 114 works was held in 1942. In 1943, bombing forced Carrà to leave Milan and settle in Corenno Plinio, near Lake Como, which inspired many landscapes of this period. He returned to Milan after the war and painted in a naturalistic style that was to remain unchanged until his death. In 1950 Carrà was awarded the Grand Prize at the XXV Venice Biennale. Thereafter his work was shown in exhibitions throughout Europe, culminating in a major retrospective at the Palazzo Reale, Milan, in 1962. Carrà died at Forte dei Marmi in 1966. [H. C.]

GIORGIO DE CHIRICO (1888-1978)

De Chirico was born on 10 July 1888 in Volos, Greece, to Italian parents. He began studying painting in Athens in 1903 and continued his studies at the Accademia in Florence from 1905 to 1906. He then moved to Munich and attended the Akademie der Bildenden Künste where he remained until 1910. In Germany, De Chirico came under the influence of the Symbolists Max Klinger, Alfred Kubin, Hans Thoma and the Swiss painter Arnold Böcklin. Literary influences such as Schopenhauer and Nietzsche, and particularly the latter's ideas of concealed realities and *Stimmung*, greatly informed De Chirico's early Parisian painting. Italian piazzas, irrational discomforting perspectives, classical statuary often copied from textbooks, long shadows and peculiar combinations of objects were primary features in De Chirico's early imagery. De Chirico exhibited at the Salon d'Automne (1912) and received favourable reviews from Guillaume Apollinaire and Ardengo Soffici. In 1915 when Italy entered the War, De Chirico and his brother Andrea (Alberto Savinio) returned to enlist. In Ferrara, where De Chirico was treated at a hospital for nervous disorders, he was joined by Carlo Carrà in January 1917. Briefly the two formed the "Scuola metafisica", but in less than two years their relationship had dissolved. De Chirico moved to Rome and in his many contributions to the periodical "Valori Plastici" (1918-1922) distanced himself from Carrà and his interpretation of "pittura metafisica". De Chirico became increasingly convinced of the importance of Classicism and technical precision, criticising other artists for their lack of solid academic grounding. He found inspiration in classical myths and began to make copies of Old Masters which he exhibited side by side with his Metaphysical works. De Chirico returned to Paris in 1924/1925, but continued to exhibit in Italy, notably at the "Novecento Italiano" in 1926. By the late 1920s De Chirico's work became increasingly "baroque", most often depicting mythological narratives amongst unpredictable, fantastic combinations of objects. The early works of De Chirico were of monumental significance to the emerging Surrealist group of the early 1920s. André Breton and his followers particularly admired their dream-like qualities and illogical juxtapositions, but later snubbed the artist, unable to reconcile De Chirico's fidelity to tradition with their own renegade adaptations of Freudian theory. In the 1930s De Chirico travelled a great deal between Italy and France, making an extended trip to the United States. He made a large mural for the Triennale in Milan in 1933 and worked in theatre and costume design. He returned to Rome in 1944 where he was to remain until his death. His later years were fraught with controversy as he made numerous copies of his Metaphysical works, sometimes pre-dating them. The situation was further complicated by the forgeries of his work which freely circulated, some appearing in exhibitions in the post-war period. He died on 20 November 1978. [H. C.]

Emilio Greco (1913-1995)

Greco was born in Catania, Sicily. He began sculpting at the age of fourteen, as an apprentice to a carver of funerary monuments. He visited Rome for the first time in 1933 and passed his exams at the Liceo Artistico in Palermo the following year. During the course of his military service (1939-1945) he settled in Rome, where he had his first one-man show at the Galleria del Cortile in 1946 which brought him great success. From 1948 to 1952 he was Professor of Sculpture at the Liceo Artistico in Rome, before teaching at the Accademia di Belle Arti in Carrara until 1955. He went on to become Professor for Life at the Naples Accademia di Belle Arti where he remained until 1967. In 1959 Greco began work on a set of bronze doors for Orvieto Cathedral which were completed in 1964. He was commissioned by Pope Paul VI to sculpt a monument to Pope John XXIII for St Peter's in Rome in 1965. In 1966 he made a trip to Greece to see more of the art which had long inspired him. Influenced by Etruscan, Greek and Roman art, his sculpted figures are classicised, yet bulky, often characterised by perfectly rounded heads. Life-size female figures and portrait busts dominate his oeuvre, but he also did many preparatory drawings on paper. These rarely utilise contours, relying heavily on hatching to achieve modelling and shading. [H. C.]

Renato Guttuso (1911-1987)

Guttuso was born in Bagheria, near Palermo on 26 December 1911. His father was an amateur watercolourist and encouraged his son to paint. From an early age Guttuso showed promise and he began to sign copies of his Sicilian landscapes from the age of thirteen. Into early manhood he visited the studios of the post-Impressionist Domenico Quattrociocchi and Futurist Pippo Rizzo among others. He participated in a group show in Palermo in 1928 and in the "Seconda mostra del sindacato siciliano" in 1929. Despite these early successes in painting, Guttuso enrolled in the Law Faculty at the University of Palermo in 1930. In 1931 two of his works were accepted at the Prima Quadriennale d'Arte Nazionale in Rome and he abandoned his studies and devoted himself to a career as a painter.

In 1932 and 1934 Guttuso exhibited with other Sicilian artists in group shows at the Galleria del Milione in Milan. With co-exhibitors Gino Barbera, Nino Franchina and Lia Pasqualino Noto, Guttuso founded the Group of Four. Brought together by a mounting defiance and aversion for Fascism, these artists aimed at deriding the dominant "Novecento" style which they considered redundant. During these years Guttuso worked as a picture restorer and a window dresser befriending members of the Roman School. In 1933 he wrote an article on Picasso who remained a lifelong influence and later was the subject of a major series of works.

While undertaking military service in Milan in 1935, Guttuso met many artists who would later participate in the "Corrente" Group to promote a popular, revolutionary painting. Yet Guttuso felt isolated during his time in Milan and in 1937, returned to Rome. He became a member of the clandestine Communist Party and actively challenged the increasingly restrictive policies of the regime. After the war, along with Renato Birolli, Emilio Vedova and Giuseppe Marchiori, he founded "Fronte Nuovo delle Arti", unified in their belief of the social responsibility of the artist. They held their first exhibition in Milan in 1947. Guttuso championed and adopted Social Realism, believing that politically relevant art depended on subject matter drawn from everyday life rendered in an easily understood style. His paintings of the late 1940s and early 1950s included workers, farmers and the landscape of his native Sicily; his range of subjects expanded thereafter to include the alienated city dweller. In England, where he exhibited at the Leicester Galleries in 1955, his work was championed by the artist Peter de Francia and the critic John Berger.

In the early 1950s Guttuso began working in theatre design, an activity that would continue throughout his lifetime. He was pivotal in the organisation of the major Picasso show in Rome (1953) and regularly exhibited at the Venice Biennale and abroad, showing at the Pushkin Museum, Moscow and the Hermitage Museum, Leningrad in 1961. The Stedelijk Museum in Amsterdam gave him a major retrospective the following year.

Guttuso taught at the Accademia di Belle Arti from

1966 to 1968. In his later years he was bestowed with many honours including the Lenin Prize for Peace, given to him at the time of his exhibition at the Art Academy in Moscow (1972). Guttuso continued to paint in a realistic style throughout the last years of his life. He died on 18 January 1987. A funerary monument by his friend Giacomo Manzù stands in the grounds of the Guttuso Museum in Bagheria, Sicily. An archive to Guttuso is run by his adopted son Fabio Carapezza Guttuso. [H. C.]

GIACOMO MANZÙ (1908-1991)

Manzù was born on 22 December 1908 in Bergamo. He was apprenticed to carpenters and woodworkers from the age of eleven and later worked as a stucco-decorator. During his military service in 1927 he took classes at the Accademia in Verona, but was otherwise self-taught. His earliest and strongest influence was Donatello. He settled in Milan in 1930, where he was subsequently awarded a commission for a series of bas-relief panels for the chapel of the Catholic University. Manzù's sculpture of the early 1930s was dominated by Biblical subject matter modelled on the primitivism of Early Christian Art. Throughout the 1930s and 1940s he returned to bas-relief as a means of exploring spatial relationships between figures in a sculptural idiom. In 1938 Manzù returned to Paris and visited the Rodin Museum for the first time. The following year the Galleria della Cometa hosted Manzù's first one-man show, presented by Carlo Carrà. Works displayed showed that Manzù had studied the sculpture of Medardo Rosso. Manzù stood apart from the various pre-war groupings of artists, but did exhibit with the "Corrente" artists in 1939, sympathising with their anti-Fascist position. The Brera Academy simultaneously nominated Carlo Carrà, Felice Casorati, Marino Marini, and Manzù to professorships in 1940, but the latter was transferred to Turin. In the same year, Manzù completed a full-scale nude portrait of thirteen-year-old Francesca Blanco which won him the Grand Prize at the Rome Quadriennale of 1942. Bronze reliefs of the "Crucifixion of Christ" (1942) which Manzù showed at the Barbaroux Gallery were condemned by the Church and the Fascist goverment and Manzù retreated to Clusone, near

Bergamo until the end of the war. The Venice Biennale of 1948 proved a watershed in his career and the beginning of a period of renewed activity. He won a Gold Prize for his series "Cardinals", which would eventually number more than fifty figures of various types. Established as a sculptor of religious imagery, Manzù was commissioned to make a set of doors for St Peter's. Originally undertaken on the theme of "Triumph of the Saints and Martyrs of the Teaching and Professing Church", this difficult work took until 1964 to complete, and was only done so when the subject was changed to that of death. By this time Manzù had achieved critical acclaim internationally.

While teaching at the Salzburg Summer Academy in 1954 he met Inge Schabel, a dancer and model. She later became his wife and was the inspiration for a series of dancing figures. In 1964 Manzù moved to Ardea and there in 1969 he set up a museum (Raccolta Amici di Manzù). He donated his collection to the Italian State in 1979. He continued to work until his death, on theatre projects and sculptural works, receiving recognition both in Italy and abroad. Manzù along with Arturo Martini and Marino Marini are an artistic trinity noted for the rebirth of Italian sculpture in the twentieth century. Manzù died on 17 January 1991. [A. N.]

MARINO MARINI (1901-1980)

Marini was born on 27 February 1901 in Pistoia to a family of bankers. In 1917 Marini enrolled at the Accademia in Florence, initially studying painting with Galileo Chini. Fascinated by Etruscan sculpture, Marini opted to continue his studies in the sculpture department under Domenico Trentacoste. Etruscan art, Auguste Rodin and Medardo Rosso were his early influences, as was Arturo Martini who, until 1929, preceded him as Professor at the Istituto Superiore per le Industrie Artistiche in Monza. In 1929 Marini exhibited with the "Novecento Italiano" and travelled to Paris where he met Aristide Maillol and Picasso among others. Marini travelled for much of the 1930s: he was in Paris in 1930, 1931, 1936 and 1938 mixing with fellow artists Campigli, De Chirico, Magnelli and Savinio; Germany in 1934 and Greece in 1935. As Marini matured, he

came to favour sculpture over painting. In the late 1930s horses and riders emerged as a dominant subject, remaining so for the duration of his career. During the Second World War this once heroic theme became a metaphor for suffering. The previously plump, sated horses, influenced by T'ang Chinese sculpture, were replaced by taut, distressed animals. In 1940 Marini relinquished his teaching post at Monza and began to teach at the Brera Academy, Milan, until he was forced to evacuate in 1942. He spent the duration of the war in Tenero-Locarno, Switzerland and made frequent trips to Basel and Zurich, where he met Giacometti. In 1939 he began his "Pomona" series of fecund female figurines which represented timeless incorruptible beauty for Marini. Taken up many times in his career, the subject balanced the increasing negativity with which he imbued his horses and riders.

Marini returned to Milan in 1946. The horse and rider theme took on a terrible significance in the post war years, recalling the human tragedies that had occured between 1939 and 1945. In the "Miracolo" series, riders were thrown from their steeds, often under the threat of capture. In 1948 Marini met Curt Valentin and Henry Moore at the Venice Biennale, and Marini showed at the former's New York gallery in 1949, which contributed to his great success in the United States. In 1952 Marini was awarded the Grand Prize for Sculpture at the Venice Biennale and the following year established a studio in Tuscany. In the "Warriors" series (begun in 1956) and "Screams" (early 1960s), Marini's horses and riders are wounded, fractured and reduced to spare geometric forms. It was also during this period that Marini returned to painting. He died on 6 August 1980. [H. C.]

AMEDEO MODIGLIANI (1884-1920)

Modigliani was born in Livorno on 12 July 1884. There he began painting in the studio of Gugliemo Micheli, a painter working in the "Macchiaioli" style, before spending brief periods at the academies of Florence and Venice. He moved to Paris in 1906. Like many of his Italian contemporaries including Ardengo Soffici and Alberto Magnelli, Modigliani studied and appreciated the works of Trecento and Quattrocento masters in the early years of the century. However, their influence was not immediately felt. Modigliani's earliest surviving works reveal Symbolist leanings and the influence of Cézanne whose major retrospective was held in Paris in 1907. Towards 1910 Modigliani's interest in the Italian Primitives was supplemented by his attraction to African and Oceanic sculpture which was then in vogue with the Parisian avant-garde. From these diverse influences Modigliani developed a repertoire of generically primitive forms and conventions: elongation, sinuous lines, vacuous eyes, ovoid heads and planar, geometrically flattened features formed the basis of his art for the duration of his career. He met the Rumanian sculptor Constantin Brancusi in 1909. By 1915 Modigliani had completed about twenty-five works in stone, the vast majority of which were symmetrical, highly stylised heads which owed a debt to Brancusi. It is the latter's influence which remains one of the few traceable links between Modigliani and the artists who surrounded him. Although well-recognised by his peers, such as Guillaume Apollinaire, Modigliani isolated himself from the effects of Cubism and other European avant-garde movements. He declined Severini's invitation to join the Futurists in 1910 and sparked a violent argument between himself and Picasso which terminated their relationship around 1915.

Modigliani met the distinguished dealer Paul Guillaume in 1914, who acted on his behalf until 1916 before relinquishing control to the Polish born poet, Leopold Zborowski (initially unexperienced in the selling of pictures). It was during this last period of Modigliani's life, from 1916 until his premature death, that his art reached its peak. He painted a series of nudes in 1916 and 1917 which caused a scandal; his painterly inclusion of pubic hair and the unabashed gazes of the figures too closely resembled the pornographic photographs of the day. During a stay in the South of France he briefly experimented with landscape painting (four of which survive); these are the only images in Modigliani's work that are not figurative or concerned with portraiture. The latter dominated in the last years of his life, as Zborowski arranged for his own friends and

family members to be sitters. Modigliani's health, which had been in jeopardy since childhood, rapidly declined as his use of drugs and alcohol escalated. He died of nephritis on 24 January 1920. [H. C.]

GIORGIO MORANDI (1890-1964)

Morandi was born on 20 July 1890 in Bologna. In 1907 he enrolled at the Accademia di Belle Arti receiving his diploma in 1913. He studied the works of Paolo Uccello, Giotto and Masaccio in Florence, and collected black and white reproductions of paintings he was unable to see at first hand, particularly those by Cézanne, André Derain and Henri Rousseau. In 1912 he began to teach himself to etch using old manuals. This was to become an enduring and important medium for Morandi. The following year he painted his first landscapes in Grizzana, outside Bologna, where his family went for their annual holidays. In 1914 he met F. Balilla Pratella and other Futurists, and exhibited at the Galleria Sprovieri in Rome later that year. However, Morandi had neither interest in the Futurist campaign, nor was he influenced by their working methods. He was chosen to represent Bologna at the "Esposizione Internazionale della Secessione" in Rome and began to teach drawing at elementary schools in Bologna. He enlisted in 1915, but was quickly discharged on medical grounds. The Metaphysical works of De Chirico and Carrà which Morandi had seen in reproduction led him to create a small number of still lifes, with groupings of enigmatic objects but by 1919 Morandi abandoned such compositions and pursued more formal qualities in his still lifes.

He exhibited in the "Valori Plastici" exhibition of 1921 which travelled to Berlin, Dresden, Hanover and Munich. Mario Broglio, who coined the term "Metaphysical Painting" and grouped Morandi with Carrà and De Chirico, was the editor-publisher of the Roman journal and the first serious collector of Morandi's work. Morandi also participated in the "Novecento" exhibitions of 1926 and 1929, but preferred to align himself, not with the purveyors of a monumental and nationalist art, but rather with the "Strapaese", a down-to-earth movement in touch with local cultural traditions. Mino Maccari and Leo Longanesi, the editors of the Strapaese journals "Il Selvaggio" and "L'Italiano", were instrumental in creating the myth of Morandi as an isolated figure, divorced from the artistic mainstream. Morandi stayed in Bologna, not visiting Paris until 1956, but was always well-informed about the cultural debates of his age. From 1930 until 1956 Morandi held the chair in printmaking at the Accademia di Belle Arti in Bologna, but continued to paint. His work has always been highly sought after by collectors, particularly after the publication of Roberto Longhi's *Momenti della pittura bolognese* (1935) which secured his critical reputation. He died on 18 June 1964. [H. C.]

ANTON ZORAN MUSIC (1909)

Music was born on 12 February 1909 in Gorizia, on the Slovenian border with Italy. In 1920 the family moved to Völkermarkt, Austria; Music first came into contact with art on occasional trips to Vienna and Prague where he saw the works of Secessionist painters Gustav Klimt and Egon Schiele and travelling exhibitions of French Impressionism. In 1930 he entered the Academy of Fine Arts in Lublijana, studying with Babic, a frequent exhibitor at the Venice Biennale and an enthusiastic admirer of Goya. Upon completion of his studies, Music travelled to Madrid with Babic where he copied the works of Goya and El Greco; Music remained there until the outbreak of the Spanish Civil War. He then returned to Curzola, Dalmatia; the dusty hills of this region would greatly influence the choice of his subject matter and his palette.

In 1939 Music returned to Gorizia where he stayed until 1943 before going to Venice. He exhibited in both Trieste and Venice before he was arrested by the Gestapo in 1944. Suspected of collaboration with anti-German groups, he was sent to Dachau where he stayed until the camp was liberated by the Americans. He secretly recorded the horrors around him in drawings. The recurrent series "We Are Not the Last" (1970, 1987) featuring the tortured, anguished faces of the dying and piles of emaciated corpses, has its source in Music's memories of Dachau. Following the war, Music painted unpeopled landscapes, hills and groups of patterned horses in dry, muted tones. Partly inspired by the countryside

surrounding Siena, which he saw on train journeys to Rome, Music's landscapes are a metaphor for timelessness and evoke an otherworldly atmosphere. In 1948 Massimo Campigli introduced Eric and Salome Estorick to Music and his wife, the painter Ida Barbarigo. The Estoricks collected the work of both artists and developed a long and close friendship which was to last until their deaths. In the early 1950s Music began to exhibit regularly in international exhibitions. A showing in 1952 at the Galerie de France led to the offer of a lucrative contract which allowed the artist to establish himself in Paris. He leased an apartment the following year from his friend Brassaï, the Hungarian photographer, while maintaining a studio in Venice. In 1954 he had his first exhibition in New York at the Cadby-Birch Gallery and in 1955 he showed in London at the Arthur Jeffress Gallery. It was at this time he began painting in watercolour, a medium he continued to use throughout his career. In the late 1950s he made his first return visits to Dalmatia and spent his summers there.

Music has continued to exhibit internationally since the 1950s and has always sought new subjects: a series of paintings based on the forest at Fontainbleau and the Dolomites entitled "Rocky Landscapes" (1976-1980), drawings from around Venice (1981-1982), interiors of cathedrals (begun in 1984) and a series of self portraits (1987). His most recent major retrospective was held at the Grand Palais, Paris in 1995. [A. N.]

Ottone Rosai (1895-1957)

Rosai was born in Florence and enrolled at the Istituto di Arti Decorative aged eleven. He was later dismissed from the Accademia di Belle Arti after a disagreement with an instructor. Around 1912 his circle of friends grew to include the *literati* of Florence: Giovanni Papini and Aldo Palazzeschi. Papini introduced Rosai to the Futurists in 1913, on the occasion of the Futurist exhibition sponsored by "Lacerba". Rosai began painting in a Futurist style and exhibited in the "Pittura futurista" exhibition at the Galleria Sprovieri, Rome in 1914. He participated in *serate futuriste* in Florence and occasionally contributed to the journal "Lacerba".

Rosai fought in the First World War as a grenadier and was wounded twice. During his period of recuperation he did portraits of fellow soldiers and still lifes. His wartime experiences inspired his books *Il libro di un teppista* (1919) and *Dentro la guerra* (1934). After the war he continued to paint in a Futurist idiom and exhibited in the "Grande Esposizione Nazionale Futurista in Milan" (1919). However, by 1920 he had replaced his earlier approach with a solemn figurative art based on archaic Tuscan models. He and Ardengo Soffici became close friends and began to paint *en plein air* together.

Following his father's suicide and unsuccessful shows in Florence and Rome in 1922, Rosai's output diminished. He took control of the family woodworking business, intermittently painted landscapes, and contributed to fascist publications. It was not until 1927 that he began to paint again and exhibit regularly. The Venice Biennale (1928) and the "Seconda Mostra del Novecento Italiano" both showed examples of his work. The Galleria del Milione held a Rosai exhibition in 1930, which proved a financial failure. Distraught, Rosai stopped painting for a year and in 1932 ended his long-term friendships with Soffici, Papini and Carrà, by publishing a highly critical pamphlet *Alla Ditta Soffici-Papini & Compagni*. Throughout the 1930s Rosai showed at the Venice Biennale, the Rome Quadriennale and held solo exhibitions in Florence and Milan. His painting underwent a marked shift in style by the mid-1930s and his new approach owed much to Impressionism; his naturalistic, pastoral scenes became increasingly profitable, as works sold with unprecedented success. In the early 1940s Rosai adopted religious subjects, but this new theme was sharply interrupted. Rosai, aligned with the Fascist movement since its beginnings, was brutally attacked by anti-Fascists in 1943 and forced to leave his teaching post at the Liceo Artistico, Florence, which he had held since 1939. In 1945 he began a series of portraits, before returning to landscape painting, and his career continued to flourish. From 1949 (the year of the monumental "XX Century Italian Art" show at the Museum of Modern Art, New York) Rosai was shown internationally until his death in 1957. [H. C.]

Medardo Rosso (1858-1928)

Rosso was born on 21 June 1858 in Turin, the son of a station-master. The family moved to Milan in 1870 where Rosso enrolled at the Brera Academy in 1882. He was expelled less than a year later for hitting a fellow student who had not wanted to sign Rosso's petition against traditional teaching methods. His time at the Academy had not been wasted as he had already produced a substantial body of work and in 1883 exhibited four sculptures at the "Esposizione Internazionale di Belle Arti" in Rome. He took subjects from everyday life - a soldier, a prostitute, old people - and revealed them, warts and all, contrary to the prevailing tradition of idealised genre sculpture. His early work is closest to the "Scapigliatura" (loosely translated as Bohemianism), a group of artists and poets based in Lombardy.

It is believed that Rosso went to Paris in 1884, where he was supposed to have met Auguste Rodin for the first time. However, in November his mother died and he returned to Milan until 1889, when he returned once again to Paris, leaving a failed marriage and child behind him. Rosso exhibited at the Exposition Universelle in that year and was befriended by Henri Rouart, a painter, who helped him by buying work and introducing him into artistic circles. It was in the 1890s that Rosso produced some of his most innovative work, which was much admired by Rodin. The fluid, malleable subtleties of wax as a medium were admirably suited to Rosso's intention to depict not only the everyday, but the fleeting, delicate interplay of light and shadow evoking the original atmosphere in which his subjects had been seen. However, despite the support and patronage of important critics and Rodin, Rosso antagonised the art establishment with his views. By 1898 his friendship with Rodin waned; Rosso believed that Rodin's "Balzac" borrowed from Rosso's style without acknowledgement. By 1910 Rosso concentrated on re-working old themes and making casts of existing models. His health was poor and he turned more to sketching than sculpting. He died on 31 March 1928 after an operation to amputate his leg. [A. N.]

Luigi Russolo (1885-1947)

Russolo was born on 7 May 1885 in Portogruaro into a musical family. He moved to Milan aged sixteen and decided to become a painter. He trained with an art restorer, Crivelli, and worked with him on Leonardo da Vinci's "Last Supper". He first exhibited a group of etchings in 1909 at the Famiglia Artistica, where he met Boccioni and Carrà. The three persuaded Marinetti of the potential for Futurist painting and in 1910 Russolo signed the *Manifesto of Futurist Painters* and *Futurist Painting, Technical Manifesto*.

The few paintings Russolo exhibited under the Futurist banner date from 1911 to 1913. Thereafter he turned to musical forms of expression, which represented his greatest contribution to Futurism. Although F. Balilla Pratella held the position of official Futurist composer and musician, Russolo wrote his own manifesto, *The Art of Noises,* which was later published in expanded form as a book (1916). In the manifesto he called for the integration of unconventional organic and industrial sounds into musical composition. The development of "noise-spirals" (waves of sound emulating and glorifying the music of the machine age) followed. In 1913 Russolo and the painter, Ugo Piatti, developed and constructed the first *intonarumori,* boxed instruments capable of generating a variety of booms, wails, hisses, crackles, shuffling and buzzing sounds. These were woven into compositions using a new and ultimately influential system of notation, *Grafia enarmonica per gli intonarumori.* Russolo gave a series of controversial performances in Modena and Genoa in the summer of 1914 with twelve consecutive evening performances at the London Coliseum. The instruments themselves were the focus of positive interest from musicians such as Igor Stravinsky and Sergei Prokoviev.

In late 1915 Russolo signed the manifesto *Italian Pride*. He volunteered for the Front and in 1917 suffered serious injury. After a delayed recovery Russolo continued to develop and broaden the range of sounds produced by the *intonarumori*. In 1919 he contributed to Le Théâtre Aérien Futuriste, harnessing the sound of an aeroplane engine. In 1921 in Paris, Russolo and Ugo Piatti produced a major

series of concerts, incorporating music composed by Russolo's brother, Antonio, and performed on multiple *intonarumori*. These concerts attracted the attention of the composers Honegger, Milhaud, Ravel and Varèse as well as prompting positive reviews from Piet Mondrian.

As the 1920s progressed, Russolo spent more time in Paris. There he developed the *Rumorarmonio* or *Russolofono*, an organ-sized keyboard instrument capable of combining the sounds of individual *intonarumori*. In 1927 he played the *Russolofono* at the Futurist Pantomime Theatre at the Théâtre de la Madeleine and later on film scores with Marinetti. Russolo gave his final concert, presented by Varèse in 1929 at Galerie 23. He returned to Italy in 1932, leaving his instruments in storage in Paris, where they were destroyed during the Second World War. After a brief period producing Realist paintings, none of which survive, Russolo went to Spain between 1931 and 1933 to study occult philosophy, later publishing a treatise entitled *Al di là della materia* (1938).

During the 1940s Russolo began to paint again, holding his first ever one-man exhibitions in Como (1945) and Milan (1946). He died the following year at his home on Lake Maggiore. [H. C.]

GINO SEVERINI (1883-1966)

Born on 7 April 1883 in Cortona, Severini moved to Rome in 1899. He worked as a book-keeper and with the help of a benefactor attended the Scuola Libera del Nudo, where he and Boccioni studied with Balla. The two adopted their instructor's Divisionist techniques and socialist stance. Severini exhibited in the "Società Amatori e Cultori" exhibition (1903), but the following year his works were rejected, prompting him and Boccioni to organise their own "Mostra dei Rifiutati" (1905). Severini went to live in Paris in late 1906, became friends with Modigliani and was soon familiar in avant-garde circles.

Encouraged by Boccioni, Severini joined the Futurists in 1910, attracted by their enthusiasm for modern technology. Severini applied Futurist principles to subjects derived from the flamboyant café and cabaret life of Paris. Dancers, which formed the basis of his movement studies, became his own paradigm for "dynamism". Severini had a pivotal role in promoting Futurism abroad, organising Futurist exhibitions in Paris and acting as an intermediary between the Futurists and the Parisian avant-garde. Severini exhibited with the Futurists in the travelling exhibitions of 1912 and had a one-man exhibition at the Marlborough Gallery in 1913. Barred by illness from joining up in 1915, Severini supported Futurist intervention with paintings glorifying the trains supplying the Front.

From 1916 Severini's approach underwent a radical revision as he responded to the greater European call to order, emphatically exemplified in his portraits "Maternità" and "Portrait of Jeanne" (Jeanne Fort, daughter of Symbolist poet Paul Fort, married Severini in 1913). He simultaneously worked in a Synthetic Cubist style influenced by Pablo Picasso and Juan Gris with whom he worked closely during the war years.

In the early 1920s Sir George Sitwell commissioned Severini to paint a series of frescoes for his villa near Florence based on the theme of the "Commedia dell'arte". Completed in 1922, the series transformed Severini's art, and the use of harlequins signalled a renewed interest in specifically Italian subject matter. Painted in a hyper-realist style, Severini turned towards naturalism, leaving his avant-garde experiments behind. With his conversion to Catholicism in the early 1920s, Severini made new contacts and obtained commissions for frescoes in Swiss and German churches throughout the latter half of the decade. Severini participated in the "Novecento Italiano" exhibitions of 1926 and 1929. At this time he also painted a series of naturalistic still lifes with classical elements, derived from wall paintings recently excavated at Pompeii and Herculaneum. Severini exhibited at the Venice Biennale in 1932 with the group "Italiani di Parigi", including Campigli, De Chirico, Savinio and De Pisis. In 1935 he returned to Italy and was awarded the Grand Prize at the Quadriennale in Rome the following year. During the 1930s he worked on allegorical mosaics and frescoes: University of Padua (1933), Palazzo di Giustizia, Milan (1938). Severini continued to work on architectural projects after he returned to Paris in

1945. During the 1960s Severini revived the abstract and Futurist styles of his youth. In 1962, using old photographs, he undertook to replicate his early masterpiece, "Pan Pan à Monico", which had been destroyed in the Second World War. He died on 26 February 1966. [H. C.]

Mario Sironi (1885-1961)

Sironi was born on 12 May 1885 and began his career at the Scuola Libera del Nudo in 1903. There he befriended Boccioni, Severini and his instructor Balla. In the early years of the century he worked in the Divisionist style favoured by his contemporaries, although much of this work was subsequently destroyed by Sironi. By early 1915 he had moved to Milan and became aligned with the Futurists, attracted not by their aesthetics, but by the movement's pro-active political stance and the interventionist fervour which dominated Futurism's activities before and during the First World War. He exhibited in the "First Free Futurist Exhibition" (April-May 1914) and later signed the manifesto *Italian Pride* (October 1915), which called for cultural interventionism and militarism. Together with Boccioni, Marinetti, Russolo and Sant'Elia, Sironi served in the Lombard Cyclists Brigade.

After the war Sironi returned to Milan. The city's rapidly expanding industrial and residential quarters served as the dominant subject of his many urban landscapes until the mid-1920s. Although these works share the emptiness and forlorn atmosphere of De Chirico's city squares, Sironi imbued his images with an eminently modern, industrial sensibility aimed at the working class. He was an original member of the "Novecento" group and exhibited with them in 1922. Sironi abandoned easel painting in the late 1920s, thinking it to be a vestige of outmoded bourgeois individualism, in favour of more publically persuasive, monumental murals and mosaics. Largely influenced by the solid forms of Etruscan and Romanesque art, these works featured allegorical scenes of work and strength. Despite the obvious value of Sironi's educative, nationalistic images to a totalitarian regime, they prompted mixed reactions, reflecting the Fascists' ambiguous relationship towards the visual arts and its unwillingness to sanction any one type of art as Fascist art. Some hailed Sironi's work as the true interpretation of Fascism, others reviled it. Sironi was even censured by the party minister Roberto Farinacci in 1934, who called his art "degenerate". Despite this controversy, Sironi would secure commissions throughout the Fascist years. After 1945 he returned to easel painting, continuing to work until his death on 13 August 1961 in Milan. [H. C.]

Ardengo Soffici (1879-1964)

Soffici was born in Rignano sull'Arno, the son of a farmer and wine merchant. He moved with his family to Florence in 1893, enrolling at the Accademia in 1897. Later, at the Scuola Libera del Nudo, he was taught painting by Giovanni Fattori. In 1899 he founded the first of many journals ("La Fiamma") to which he would make regular contributions. He moved to Paris in November 1900, remaining there for seven years. He initially worked for the Symbolist journals "L'Assiette au Beurre" and "Plume", through which he befriended Guillaume Apollinaire. Progressively his circle of friends widened to include Braque, Derain, Dufy, Gris, Max Jacob and Picasso. After his return to Tuscany in late 1906 he maintained contact with the Parisian avant-garde and frequently returned to Paris until the First World War. In December 1907 the first issue of "La Voce" was released; Soffici contributed reviews of the latest developments in Paris, with articles on Braque, Picasso, Medardo Rosso and Henri Rousseau, among others.

In 1909 Soffici collaborated with Serge Jastrebzoff (Serge Ferat) on an Italian translation of Chekhov and published his first book, *L'ignoto toscano*, which was autobiographical in part. The following year under the auspices of "La Voce", Soffici organised an exhibition of Impressionist painting in Florence, showing the works of Degas, Monet, Pissarro and Renoir and giving over an entire room to the works of Medardo Rosso, then little known in Italy.

Soffici attended the first exhibition of Futurist painting, "Esposizione Libera", in 1911 and published a negative review in "La Voce", in which he questioned the originality of Futurist art. Boccioni, Carrà and Marinetti responded by going to Florence and

assaulting Soffici in the famous café, Giubbe Rosse. Soffici, Papini, Prezzolini and Slataper waged a counter-attack the following day at Florence railway station. All were arrested and while awaiting interrogation, Boccioni and Soffici were reconciled. By 1913 Soffici exhibited with the Futurists and gave them prime coverage in the new journal "Lacerba" which he co-edited with Papini. Throughout this period Soffici was experimenting in a variety of pictorial styles influenced by Cézanne and the Cubists.

Soffici had grown dissatisfied with Futurism by the time he volunteered for the Front in 1915. Discharged in 1919, he emerged from the experience of war extolling the value of "the simple and the true". In the early years of the century, Soffici had asserted the primacy of the Tuscan tradition (*toscanità*) to his art; in the post-war period a reverence for this tradition grew and manifested itself in the naturalistic, directly observed landscapes which remained the mainstay of his art until his death.

During the 1920s Soffici actively championed young, unknown artists such as Rosai, Morandi and Ungaretti. In 1926 he visited England for one month and the following year visited Picasso's studio for the last time. He exhibited with Carrà in Milan (1930) and was awarded First Prize at the Quadriennale in Rome the following year. In 1939 he abandoned the Accademia d'Italia, the Fascist group of sixty leading cultural figures, scientists and inventors, of which he had been a member for thirteen years. In the early 1940s he wrote for "Il Popolo d'Italia" and collaborated on a new Florentine periodical "Italia e Civiltà". With the arrival of the Allies in Italy, Soffici was placed in a camp from December 1944 until July 1945. From 1951 until 1955 Soffici published his four volume autobiography *Autoritratto di un artista italiano nel quadro del suo tempo*. He died in 1964. [H. Č.]

FINITO DI STAMPARE PRESSO
LE OFFICINE GRAFICHE EDITORIALI ZEPPEGNO, TORINO
NEL MESE DI DICEMBRE 1997

FOTOLITO FOTOMEC, TORINO